Manga Mania Romance

Chris Hart

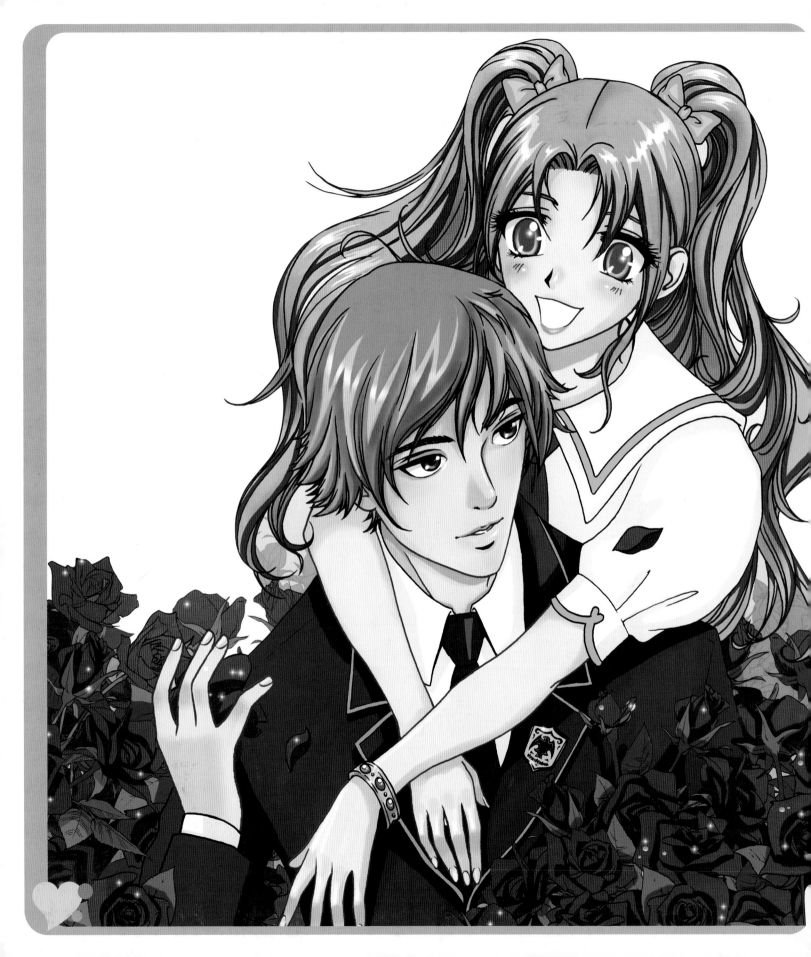

Manga Mania™ Romance

Drawing Shojo Girls and Bishie Boys

Chris Hart Books

233 Spring St.
New York, NY 10013

Editorial Director
ELAINE SILVERSTEIN

Book Division Manager
ERICA SMITH

Senior Editor
MICHELLE BREDESON

Copy Editor
KRISTINA SIGLER

Art Director
DIANE LAMPHRON

Associate Art Director
SHEENA T. PAUL

Contributing Artists
ANZU DENISE AKEMI
VANESSA DURAN IZUMI KIMURAYA
PH DIOGO SAITO
JENNYSON ROSERO NAO YAZAWA

Color and design by MADA Design, Inc.

Vice President, Publisher
TRISHA MALCOLM

Production Manager
DAVID JOINNIDES

Creative Director
JOE VIOR

President
ART JOINNIDES

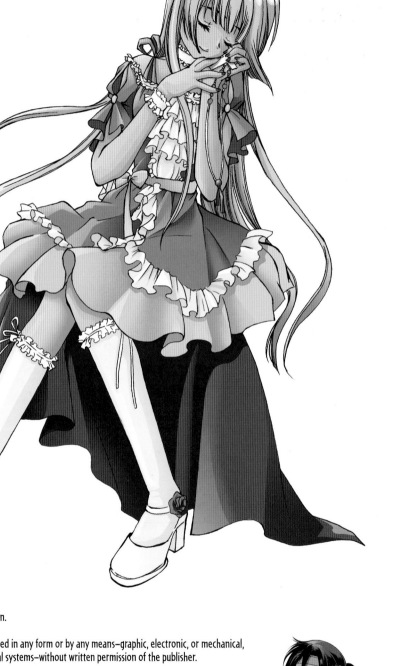

Copyright © 2008 by Art Studio, LLC
Manga Mania™ is a trademark of Christopher Hart, used with permission.

Library of Congress Control Number: 2007907250

ISBN-13: 978-1-933027-43-2
ISBN-10: 1-933027-43-6

Manufactured in China

9 10 8

4 First Edition

CHRISHARTBOOKS.com

Contents

INTRODUCTION . 9

SHOJO GIRLS: THE BASICS 10
The Shojo Girl's Head 12
 Front View . 12
 Profile . 12
 3/4 View . 14
 Looking Down . 15
 Chin Up . 15
Beautiful Manga Hair 16
 Popular Hairdos . 16
 More Gorgeous Styles 18
 Accessorize! . 19
The Shojo Girl's Body 20
 Front View . 20
 Side View . 22
 Full-Body "Turn-Arounds" 24
On the Move! . 25
 Walking . 25
 Running . 27

BISHIE BOYS: THE BASICS 28
The Bishie's Head . 30
 Short-Haired Bishie 30
 Classic Long-Haired Bishie 31
 Young Teen Bishie 32
 Confident Bishie . 33
 Intense Bishie . 34
Bishie Character Designs 35
 Classic Bishie: Front View 35
 Trendy Bishie: Side View 36
 Adult Bishie: 3/4 View 37
Guys With Glasses 38

Bishie Bodies . 40
 Standing Poses . 40
 Arm Positions . 42
 Body Angles . 44
Bishies in Motion . 46
 The Walk . 46
 Fast Run . 47
Bishie Poses . 48
 Laidback Bishie . 48
 Romantic Bishie . 49

DRAWING FABULOUS MANGA EYES 50
Girls' Eyes . 52
Boys' Eyes . 54
The Eye in Profile 55
And Don't Forget Eyebrows! 56
Expression Models 58
 Front View . 58
 3/4 View . 59
 Changing the Angles 60
 Happy Emotions . 61
 Boo-Hoo! . 62
 Surprised and Stunned 63
 Coy, Shy and Modest 64
Bishie Expressions 65
Humorous Expressions–Chibi Style! 66

COSTUME DESIGN 68
Girls' Costumes: Classic Sailor Suit 70
Girls' Private-School Outfits 74
Folds & Wrinkles . 77
Upscale Bishie Costumes 78
Casual Bishie Outfits 79

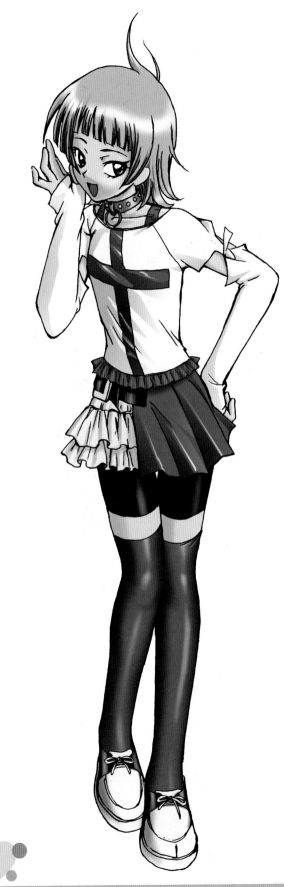

MAGICAL GIRLS80
Classic Magical Girl82
Magical Girl Princess84
Cat Girl86
Magical Girls & Their Magical Buddies!88
Rabbit-Type Magical Pets89
Hamster-Type Magical Pets90
Caring for a Sick Fantasy Pet91
Hyperactive Pets!92
Brave Little Pet93

MORE COOL BISHIES94
Bishie Fantasy Fighter96
Samurai Bishie97
Emos98
Spirit of Light100
The Mysterious Boy102
The Heartbreaker102
The Bad Boy104
They All Have a Crush on Him!106
New Kid in Town108
Mysterious Boy Outfits109

THE ABCS OF SCENE STAGING110
Drawing Two People in a Scene112
Friends Chatting112
When Boy Meets Girl114
Cosplay!115
Drawing Couples: Scene by Scene116
Action Scenes118
Group Shots Vs. "Two-Shots"120
Filling the Panel121
Extreme Drama Takes Extreme Angles122
Good Cuts & Bad Cuts124

Extreme Closeups . 126
Tilted & Odd-Shaped Panels 127
The Reveal . 128
 Embarrassing Moment Reveal 128
 Treasure Chest Reveal 129
 The Double Reveal . 129

FINISHING TOUCHES 130
Special Effects . 132
 Full-Moon Effect . 132
 Stars . 133
 Blush Clouds . 134
 Repeated Dots . 135
 Clouds of Doubt . 135
 Daydream Effect . 136
 The Burst . 137
 Broken Shards . 138
 Aroma Molecules . 139
 Red in the Face! . 139
 Dramatic Streaks . 140
 Flash of Light . 141
Speech Balloons . 142
 Positioning Speech Balloons 142
 When One Balloon Is Not Enough 143
 Special-Effects Speech Balloons 144
Japanese Sound Effects 146
Common Japanese Names 147

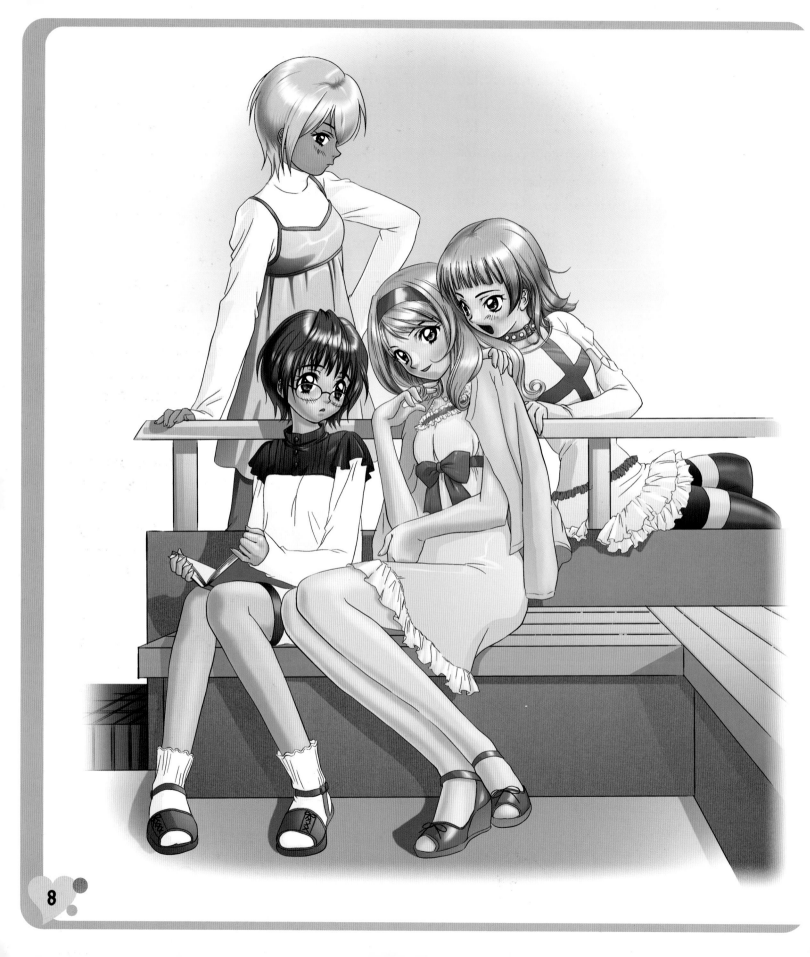

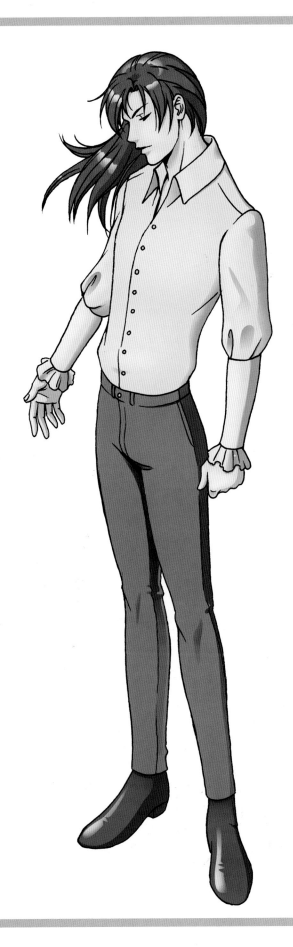

Introduction

Welcome to this special edition of Manga Mania. The romance genre is a huge favorite among manga fans. Check out the manga graphic novel section of your local bookstore or comics shop and you'll find it stuffed with romance manga. The most-read genre of manga in Japan, romance has exploded into a full-fledged phenomenon in the United States, with new titles coming out every month—and no sign of slowing down. The most popular series typically boast ten, fifteen, even twenty titles!

Manga romance stories feature high school teens, including pretty, big-eyed shojo girls, other young adult characters, and "bishies"—the handsome boys all the girls in manga stories have huge crushes on. This book is one of the first to show, in super detail, how to draw bishies. These teen idols are perhaps the biggest growth trend in manga today and appear as essential characters in all romance stories. You'll learn how to draw their unique look and a wide variety of appealing characters, including the darkly charismatic Mysterious Boy.

This book will provide you with in-depth art instruction that will raise the level of your drawing skill. The art is of the highest quality and in the authentic Japanese style.

Manga Mania Romance is also an idea book. It features plenty of story and character ideas and themes to inspire you to draw your own characters—even a cast of characters—and perhaps, if you're ambitious enough, your own graphic novel.

Because romance is such a popular genre in manga, I knew that this book had to deliver more than the typical how-to-draw books. It had to be packed with the newest trends and state-of-the-art techniques out of Japan—the things you just can't find on American bookshelves. After much research and effort, I think we've got it. And what's more, I believe it will give you the cutting edge in drawing the most popular genre of manga in the world today.

It's all in here, at your fingertips. Let's get started.

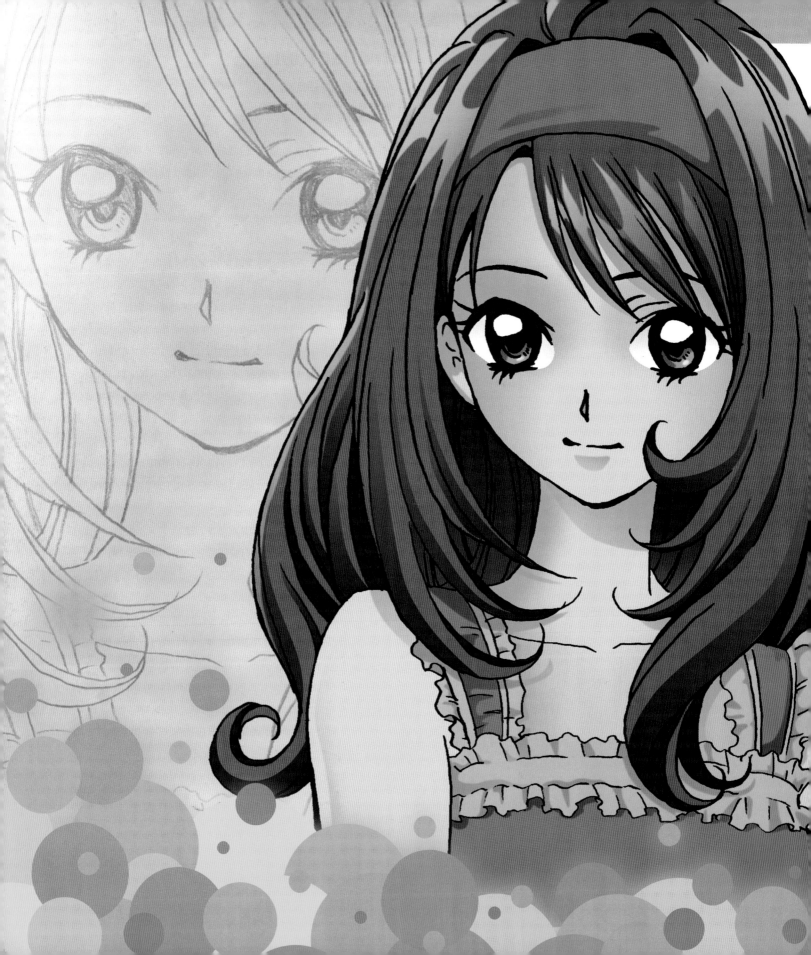

Shojo Girls

The Basics

The romance genre of manga features young characters dealing with the ups and downs of dating and breakups, gossipy cliques, and best-friends-forever. Many characters in the romance genre are drawn in the shojo (pronounced "show-joe") style. In this chapter, we'll take a close look at the pretty high school girl—the most popular of the romance characters.

The Shojo Girl's Head

The typical shojo character has oversized, sparkling eyes. The head is large and round to give the character a youthful look. And shojo girls have *lots* of hair, which exaggerates the size of the head.

Front View

Let's begin by drawing the front view. Most of us are comfortable with this angle of the head, and it will give us the confidence to try some others.

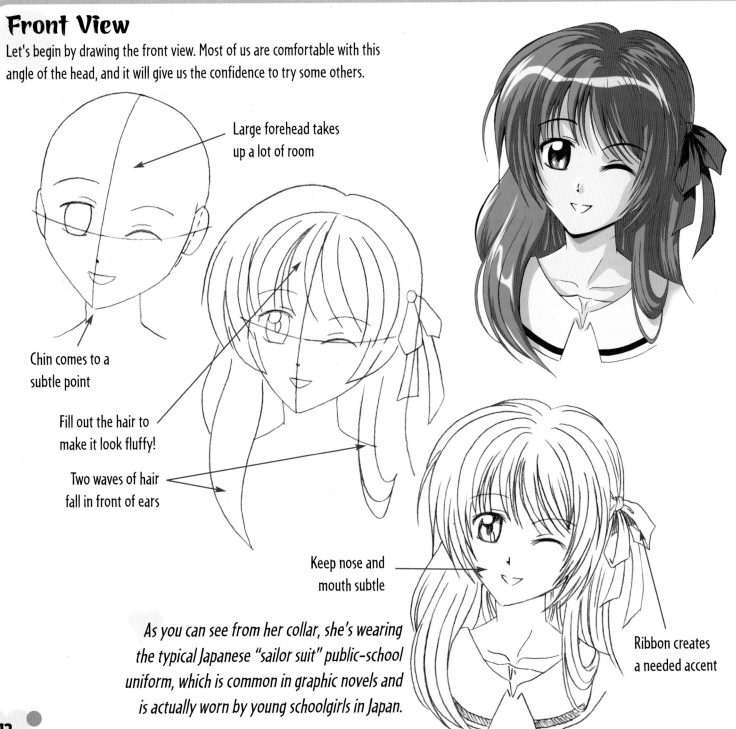

Large forehead takes up a lot of room

Chin comes to a subtle point

Fill out the hair to make it look fluffy!

Two waves of hair fall in front of ears

Keep nose and mouth subtle

Ribbon creates a needed accent

As you can see from her collar, she's wearing the typical Japanese "sailor suit" public-school uniform, which is common in graphic novels and is actually worn by young schoolgirls in Japan.

Profile

In the profile, or side view, the bridge of the nose is a sweeping curve that pulls the nose out far, in front of the face. This is an attractive look. Make this curve the foundation of the features when drawing the head at this angle.

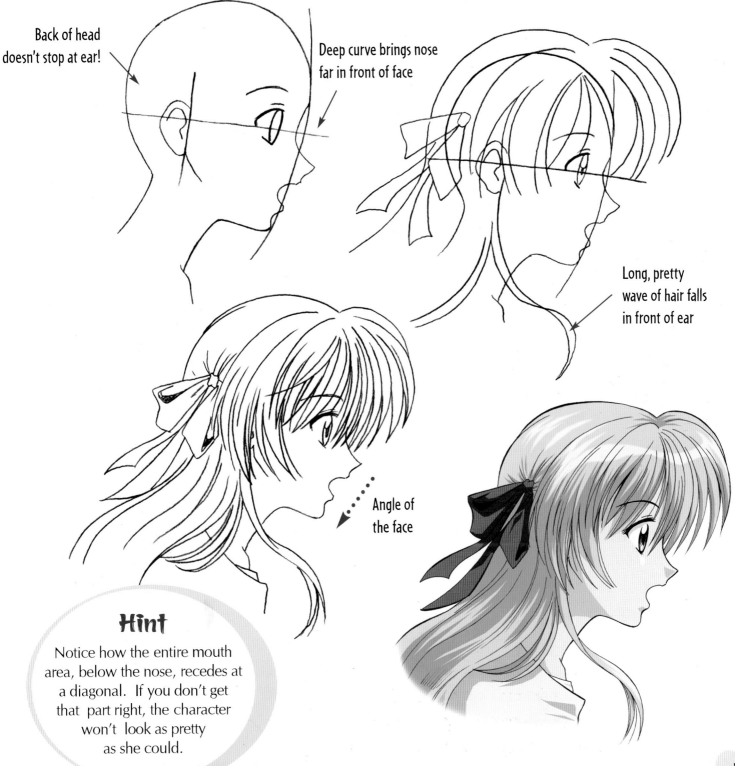

Back of head doesn't stop at ear!

Deep curve brings nose far in front of face

Long, pretty wave of hair falls in front of ear

Angle of the face

Hint

Notice how the entire mouth area, below the nose, recedes at a diagonal. If you don't get that part right, the character won't look as pretty as she could.

3/4 View

When the head is turned slightly to the side, add a lyrical touch by also lifting it up a bit, rather than keeping it absolutely straight and stiff. See how it brightens her spirit? Because the head is tilted up slightly, the eye line (along which the eyes are placed) will be slanted somewhat. Also, make sure you leave "breathing room" between the chin and the neck. A sleek neck looks feminine, so don't obscure it.

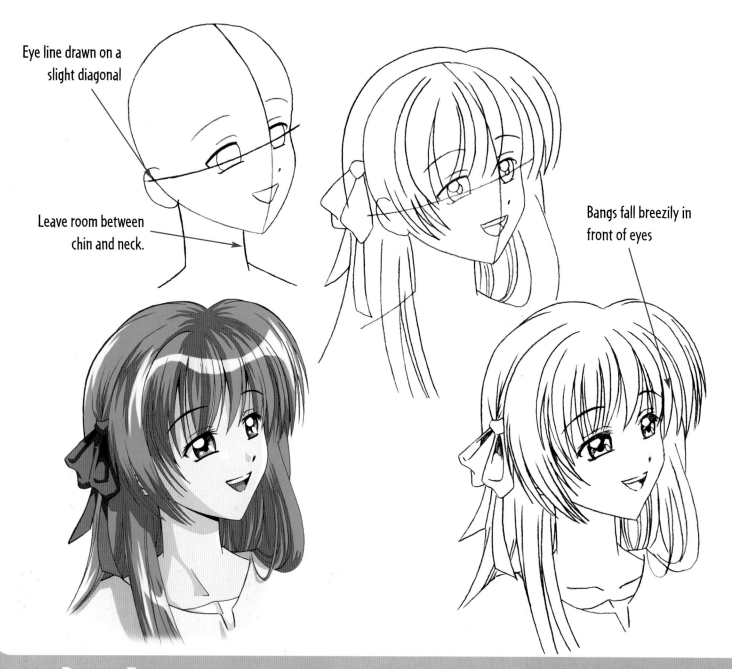

Eye line drawn on a slight diagonal

Leave room between chin and neck.

Bangs fall breezily in front of eyes

Droopy Eyes

This type of character, the sweet schoolgirl, is often portrayed with droopy-style eyes. This means that the top eyelids slant down significantly. For this look to be effective, the eye itself must be drawn very large. Droopy-style eyes are a pretty variation that is extremely popular.

Looking Down

This angle is perfect for drawing a reflective expression. Tilting the head downward conveys teenage angst. Note how we see the eyelids when the head is set in this direction. That's because we are looking at them from above. We also see more of the top of the head than at other angles. And one more thing: Adjust the nose and mouth so that they are shifted slightly farther down, toward the chin.

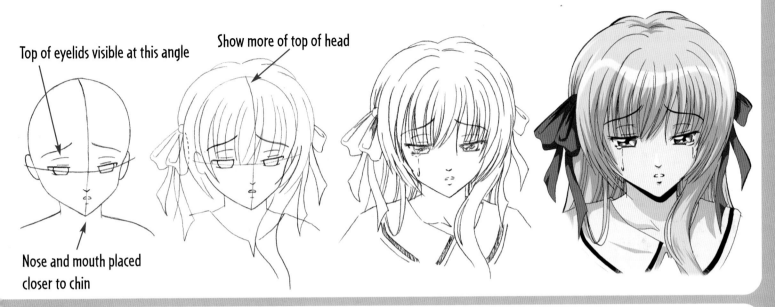

Top of eyelids visible at this angle

Show more of top of head

Nose and mouth placed closer to chin

Chin Up

Cheerful characters who are positive role models are drawn looking straight ahead, chin up. Gossips, liars and cheats look at people from the corners of their eyes, with their chins slightly down, as if they have something to hide.

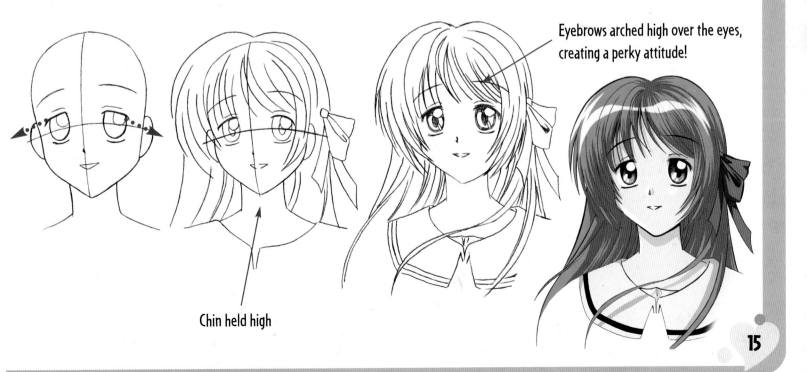

Eyebrows arched high over the eyes, creating a perky attitude!

Chin held high

Beautiful Manga Hair

Shojo girls are famous for their beautiful hair. It should always look plentiful, surrounding the head with generous amounts of waves, swirls, braids, pigtails and buns. Almost all shojo hairstyles sport long bangs.

Think of the hair as a beautiful frame for a canvas. Once you have drawn the face, don't place it in a cheap frame. Put it in the best frame possible. After all, it doesn't cost any extra. All it takes is a pencil!

Popular Hairdos

Here are a few trendy hairdos you can try on your characters to make sure they're in style.

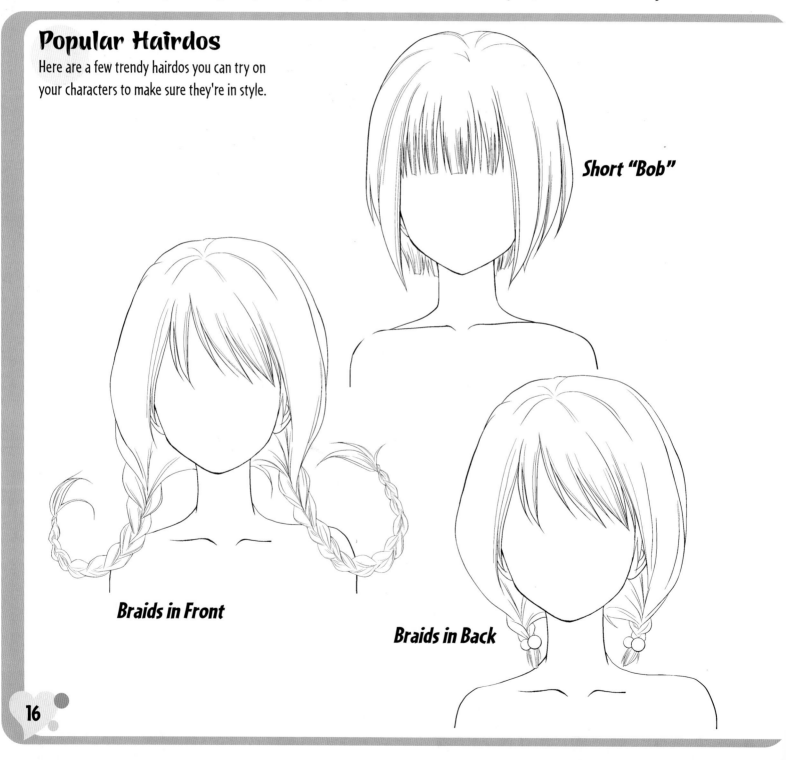

Short "Bob"

Braids in Front

Braids in Back

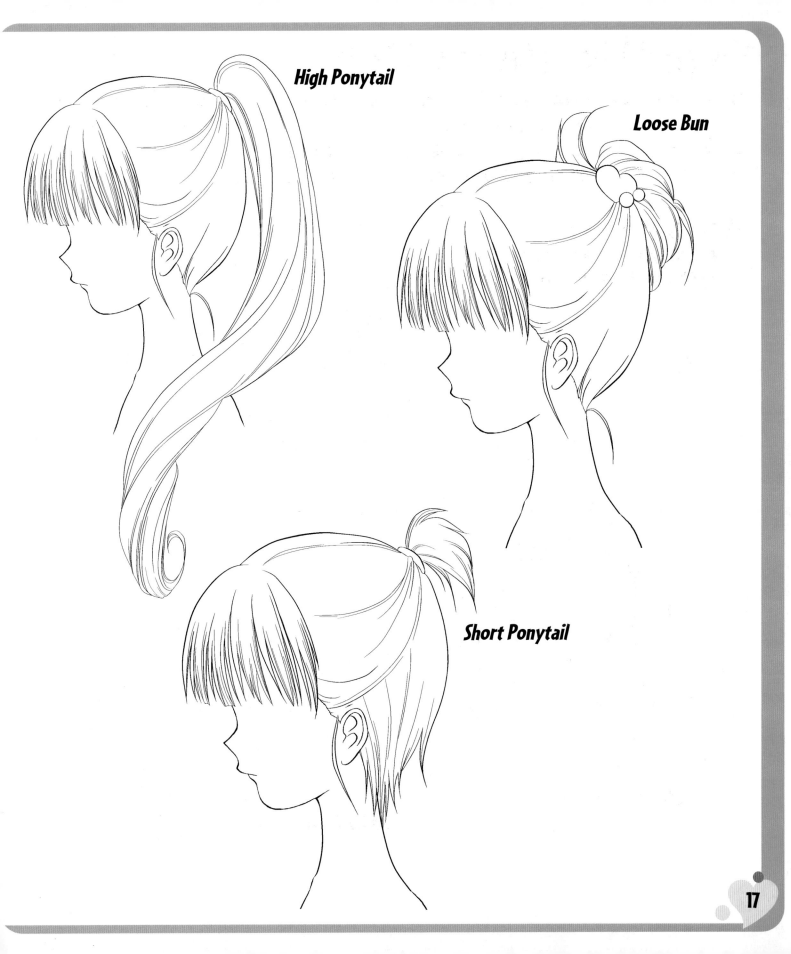

High Ponytail

Loose Bun

Short Ponytail

More Gorgeous Styles

Now let's add faces to the hair to get the full impact and glamour each style brings out. It's important to note that manga teens are drawn with more hair than actual people have—they have an idealized, fantasy version of perfect hair.

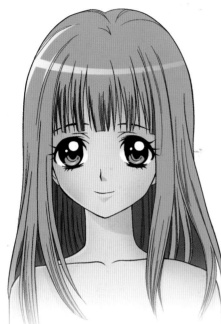

Long and Straight

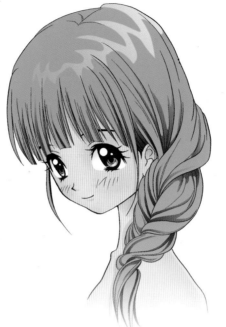

Single Thick Braid

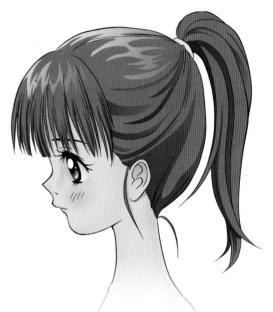

High, Unbraided Ponytail

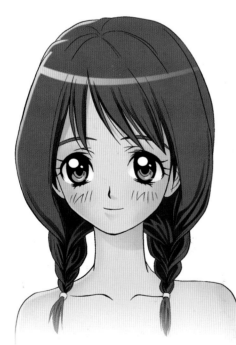

Short Braids

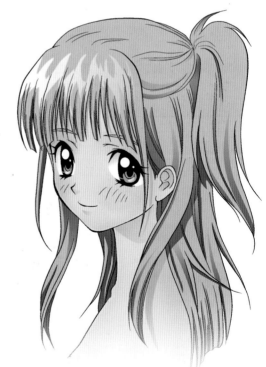

Face-framing Strands

Accessorize!

When jewelry might be too showy, smaller hair accents like these ribbons, bows and barrettes add sparkle to a character without going over the top. You can combine more than one accessory, like a barrette and a hairband, for some extra glamour.

Clip and Beaded Hairbands

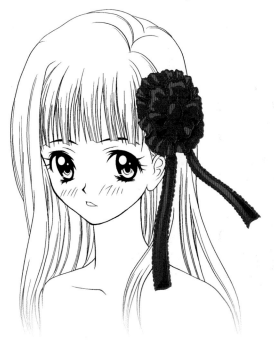

Flower Barrette

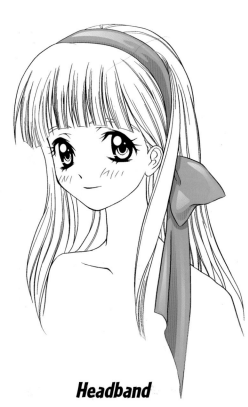

Headband

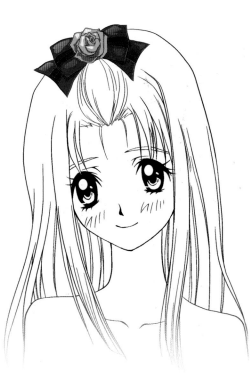

Rose-and-Ribbon Barrette

The Shojo Girl's Body

When I was learning to draw the figure in art school, I was taught to look for specific visual "cues"–the proportions and placements I had to achieve in my drawings if they were to come out looking right. This section shows you the cues you need to look for when drawing the shojo girl's body. Once your familiarize yourself with these proportions, they'll become second nature to you, and you won't have to think about them.

Front View: Super-Basic Steps

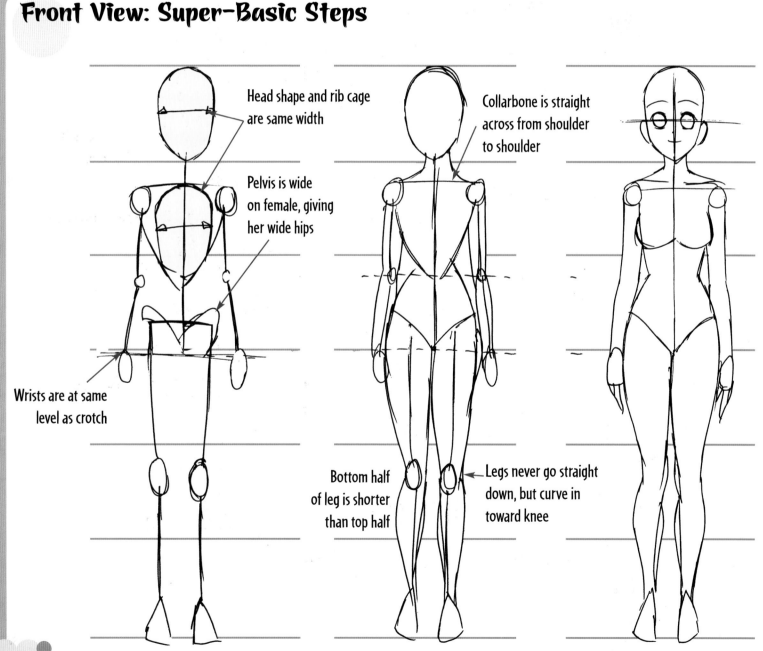

Head shape and rib cage are same width

Pelvis is wide on female, giving her wide hips

Wrists are at same level as crotch

Collarbone is straight across from shoulder to shoulder

Bottom half of leg is shorter than top half

Legs never go straight down, but curve in toward knee

Front View: Details

Here's a little secret most art instructors never tell you: Yes, the proportions are important and are the surest way to draw a convincing figure, but if you've drawn a body, and it looks good but the proportions are a little off, no reader is going to get out a ruler and check it. If it looks good, leave it alone!

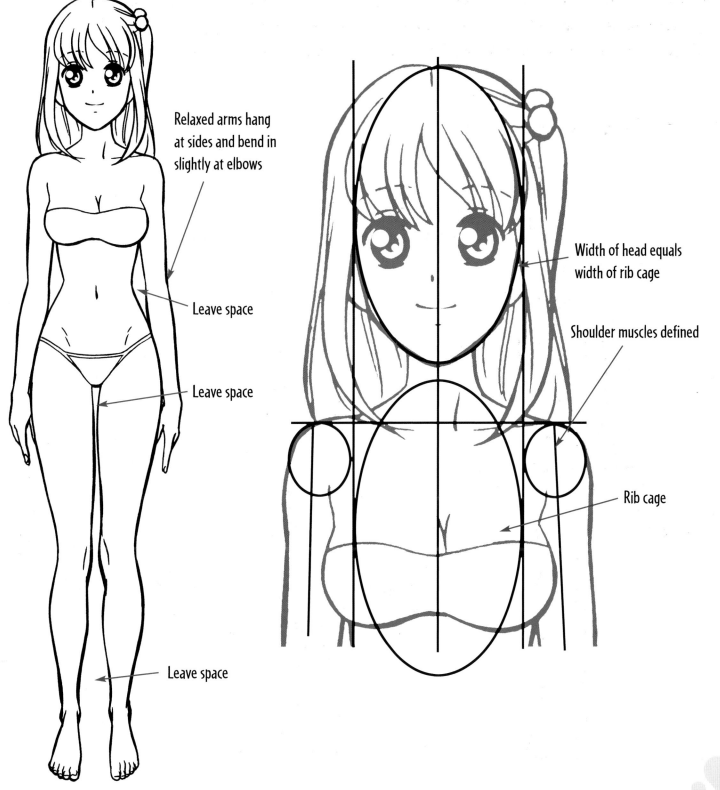

Relaxed arms hang at sides and bend in slightly at elbows

Leave space

Leave space

Leave space

Width of head equals width of rib cage

Shoulder muscles defined

Rib cage

Side View: Super-Basic Steps

Here's the secret to drawing this pose: Tilt the torso (rib cage) up and the hips (pelvis) down, as shown in the first step. It's that simple, but it will make all the difference in creating a natural-looking side pose. Your goal should be to make the character look energetic, even when she's standing still.

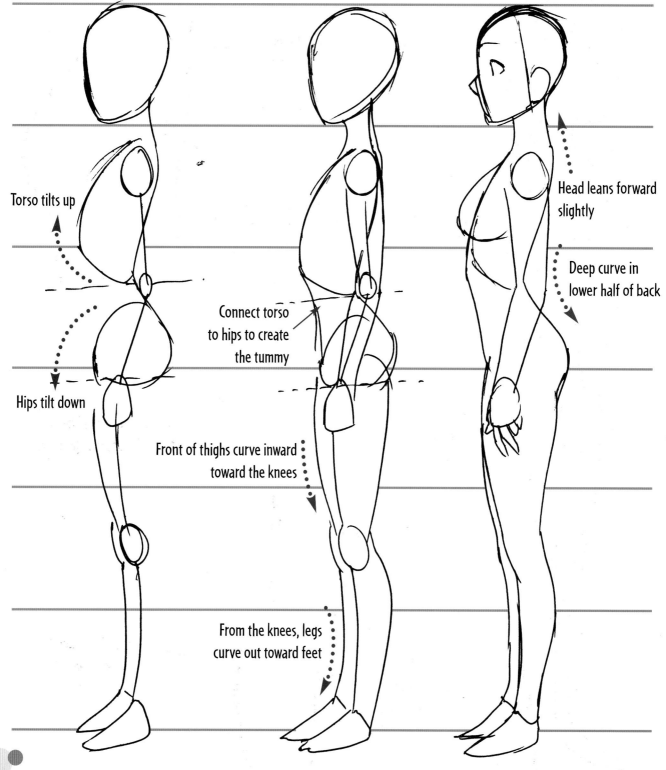

Torso tilts up

Hips tilt down

Connect torso to hips to create the tummy

Front of thighs curve inward toward the knees

From the knees, legs curve out toward feet

Head leans forward slightly

Deep curve in lower half of back

Side View: Details

Far from standing "straight as a board," the body is actually doing a lot of bending back and forth in the side view.

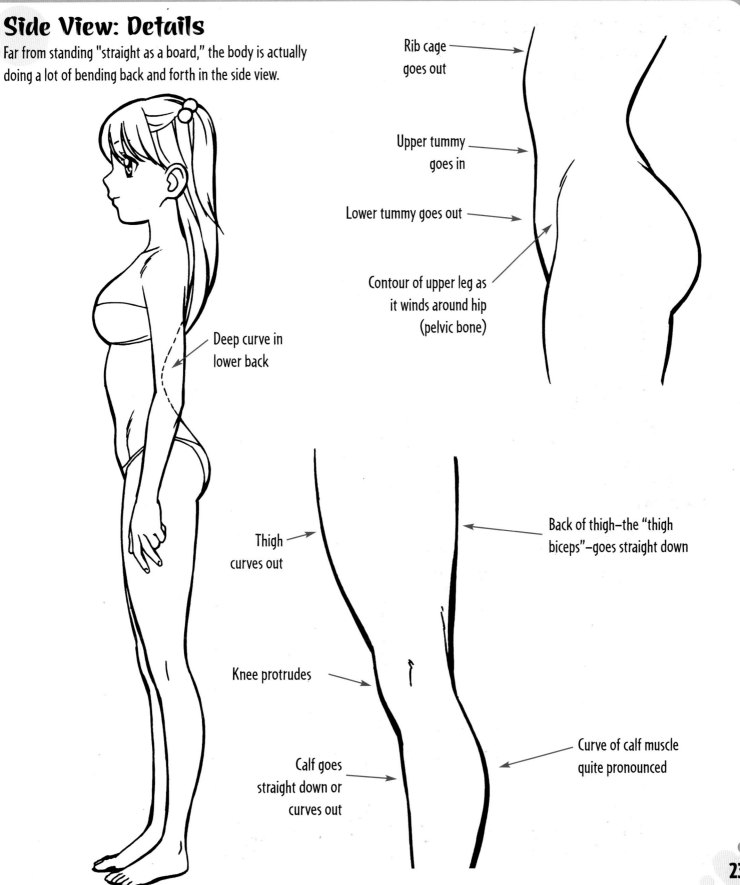

Rib cage goes out

Upper tummy goes in

Lower tummy goes out

Contour of upper leg as it winds around hip (pelvic bone)

Deep curve in lower back

Thigh curves out

Back of thigh—the "thigh biceps"—goes straight down

Knee protrudes

Calf goes straight down or curves out

Curve of calf muscle quite pronounced

23

Full-Body "Turn-Arounds"

Movie animators use "turn-arounds" from character model sheets in order to draw the character in different poses without veering off course. Manga artists also use turn-arounds to help them draw the character in different poses and at various angles from panel to panel. Here are some turn-arounds you can use to help you in drawing the shojo girl.

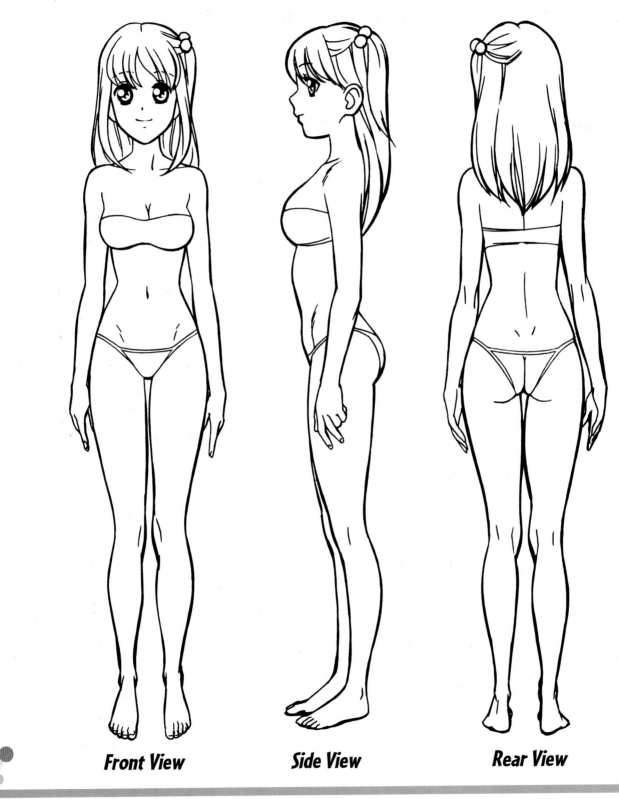

Front View **Side View** **Rear View**

On the Move!

Now we'll take it a step further and go from drawing the body standing still to actual motion poses. The most useful motion poses to learn are those that occur most frequently in stories: walking and running. Running is much more than a fast version of walking. Each gait has its own dynamics.

Walking: Front View

When a character walks, a lot more goes on than legs moving and arms swinging. The shoulders and hips must be drawn at a dynamic tilt to give the illusion that the character is walking toward us. This is especially important when depicting a character in a front view. Because without that tilt, the walk would look completely static, no matter how wide the stride is, or how well the figure is drawn.

The arrows show the direction in which the shoulders and hips must be tilted to give the illusion of motion.

Rear leg partially hidden by front leg

Front leg steps in front and in center of body

Hint

In this pose, the front leg that is coming forward actually aligns with the neck!

25

Walking: Side View

When we walk, we swing our arms. However, we can cheat a little to create a feminine look for our characters. When they walk, their arms aren't going to swing very much at all. In fact, they are going to stay mainly at their sides, and even drag behind their torso a bit.

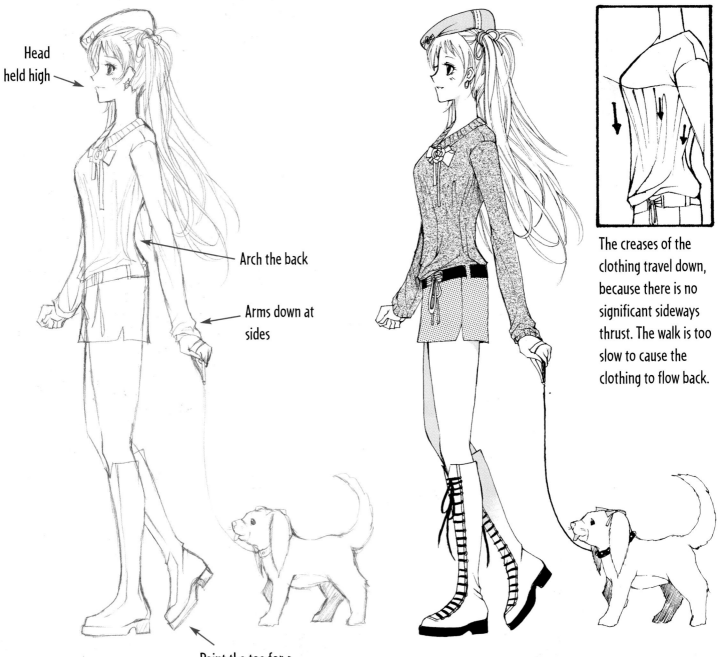

Head held high

Arch the back

Arms down at sides

Point the toe for a pretty look

The creases of the clothing travel down, because there is no significant sideways thrust. The walk is too slow to cause the clothing to flow back.

Running: Front View

This dash has our character leaning to one side rather than aligned straight up and down, making her much more dynamic. And with all that exertion, the arms have to start really pumping away! The clothes and the hair have to flap, too.

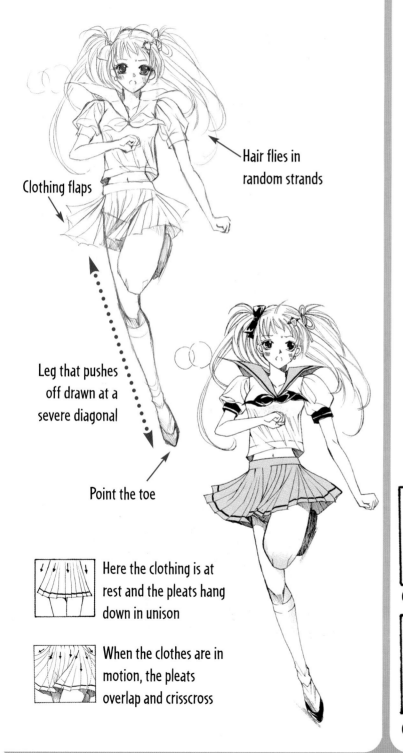

Hair flies in random strands

Clothing flaps

Leg that pushes off drawn at a severe diagonal

Point the toe

Here the clothing is at rest and the pleats hang down in unison

When the clothes are in motion, the pleats overlap and crisscross

Running: Side View

In a side view, the runner's body is angled forward and her hair flies back.

Hair in walk

Hair in run

Hips and bottom align

Hand and toes align

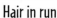

Clothes in walk

Clothes in run

Leg that pushes off drawn at a diagonal

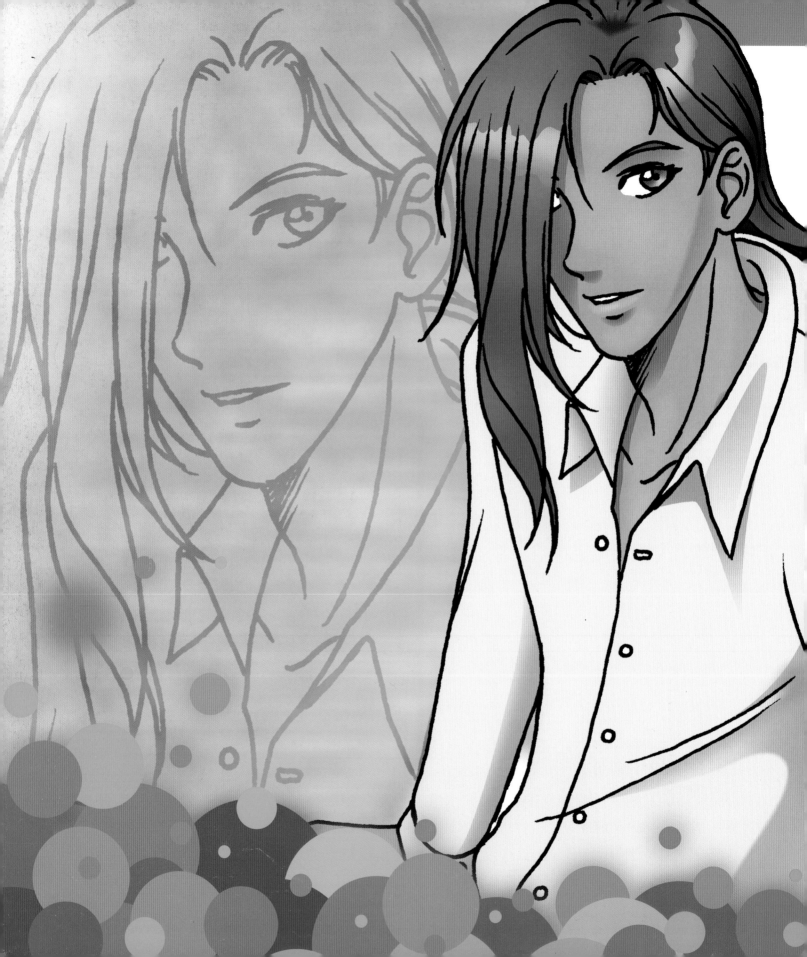

Bishie Boys

The Basics

Bishies—the teen boys of manga that all the girls have crushes on—are in all the romance graphic novels. These guys have caused more than their fair share of heartbreaks, yet the girls keep coming back for more! The bishie boy is self-confident but unable to commit. He's somewhat aloof, troubled and mysterious—in other words, "Mr. Wrong," which is why he's a teenage girl magnet.

The Bishie's Head

In the romance genre of manga, the bishie is drawn with a very distinct look, and his head is more mature than the girl's. The proportions and the features are also different. Let's take a look at the individual differences that give him a more virile, and some would say slightly dangerous, persona.

Short-Haired Bishie

This bishie sports a short haircut, but the short sketch lines give it a soft look. This version of a bishie's face is drawn with an angular jaw line. However, since the features are all delicate (a must for bishies), the angularity doesn't make him look unduly rugged, which would ruin the effect.

Pointy chin

Short, sketchy strokes make hair look soft

Soft, delicate features

Muscular, athletic neck

Angular jaw line

Classic Long-Haired Bishie

Another type of bishie has a face with a softer, less angular outline.
He has a more androgynous look and is drawn with long hair.

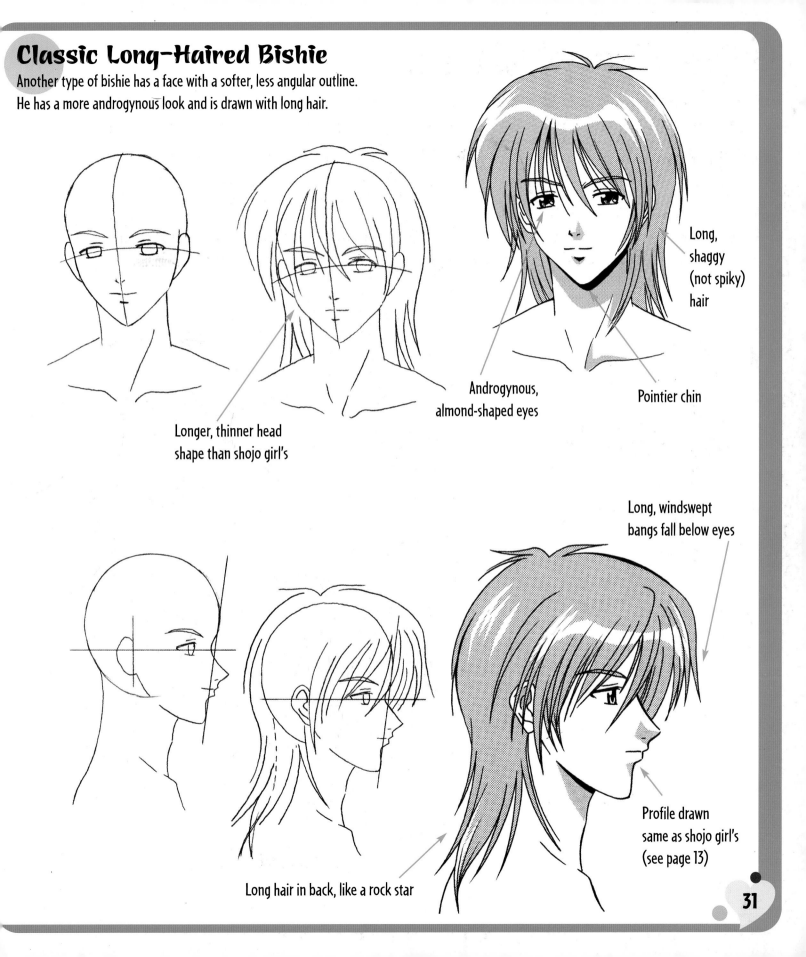

Long, shaggy (not spiky) hair

Androgynous, almond-shaped eyes

Pointier chin

Longer, thinner head shape than shojo girl's

Long, windswept bangs fall below eyes

Profile drawn same as shojo girl's (see page 13)

Long hair in back, like a rock star

Young Teen Bishie

While the romance genre tends to feature 12- to 17-year-old girls, most bishie boys appear to be older, even if they are meant to be their classmates. They usually look like they're 17 to 19 years old—even as old as 21. However, younger-looking bishies like this one are not uncommon.

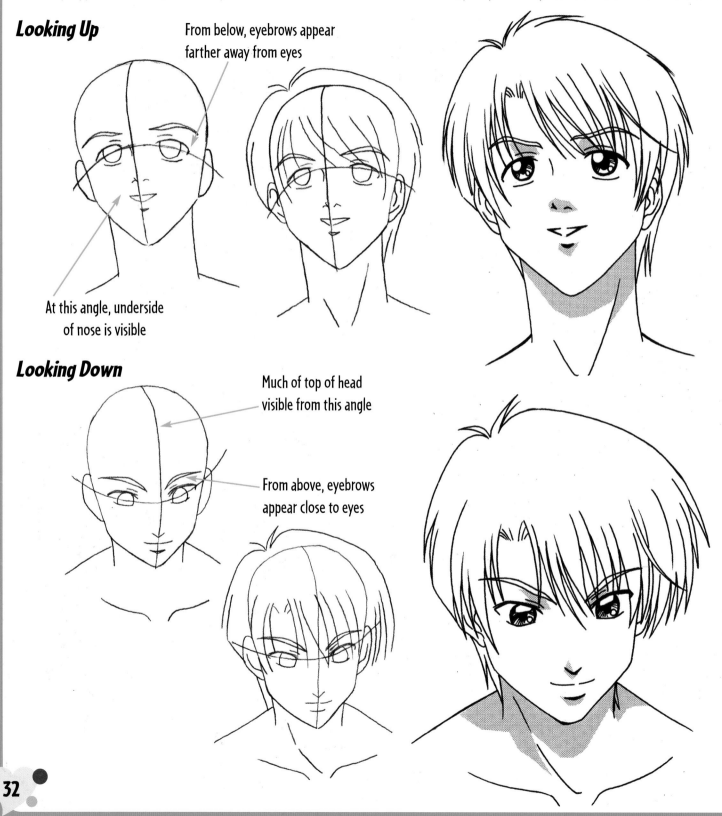

Looking Up

From below, eyebrows appear farther away from eyes

At this angle, underside of nose is visible

Looking Down

Much of top of head visible from this angle

From above, eyebrows appear close to eyes

Confident Bishie

For this bishie, we'll start with a generic head outline. Step by step we'll carve different angles from the outline until it takes on the recognizable shape of a bishie.

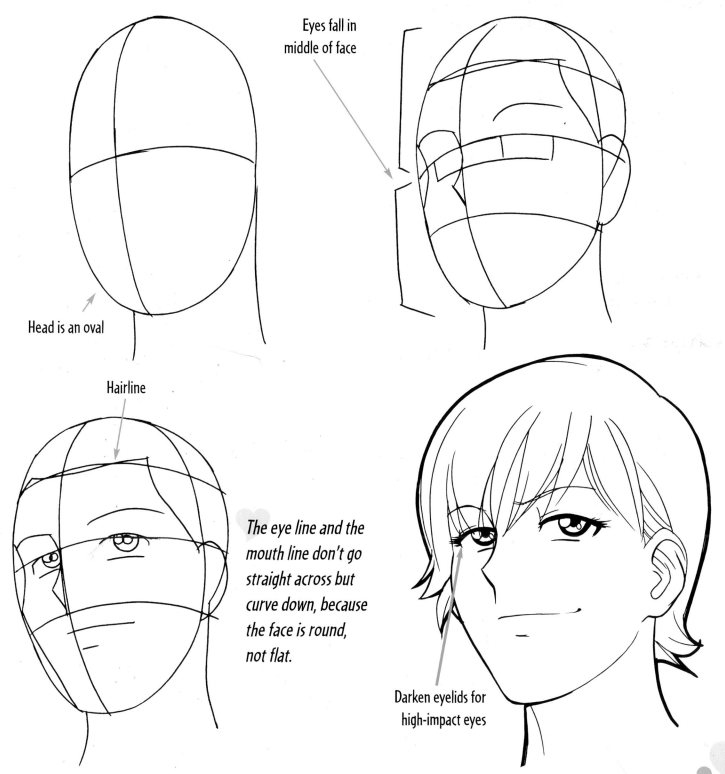

Eyes fall in middle of face

Head is an oval

Hairline

The eye line and the mouth line don't go straight across but curve down, because the face is round, not flat.

Darken eyelids for high-impact eyes

Intense Bishie

While bishies are usually reserved, they can display a full range of emotions if the situation calls for it. But you have to get them to the boiling point to see it!

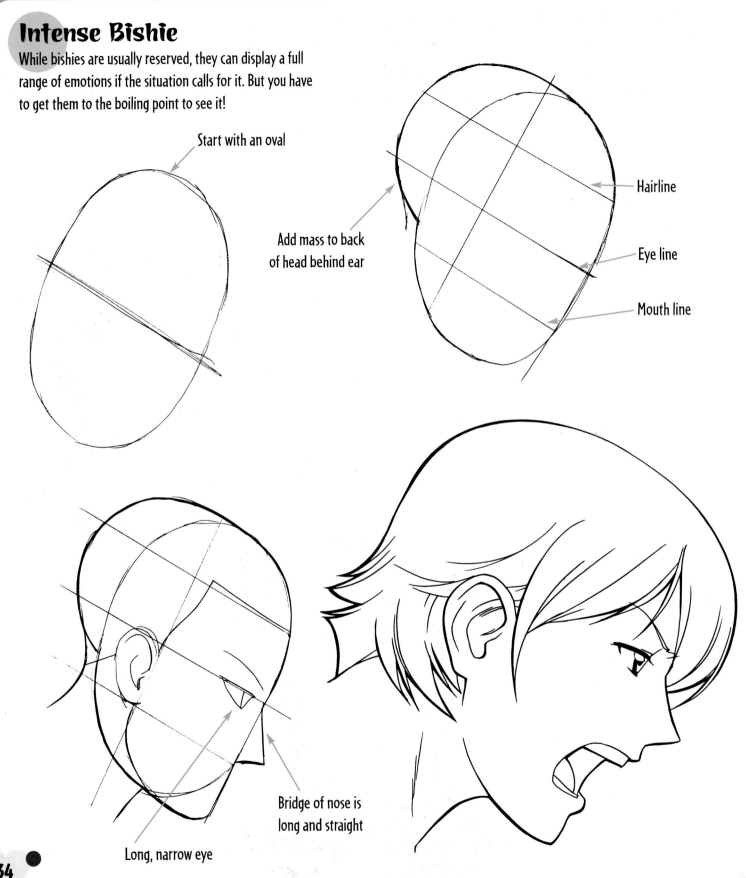

Start with an oval

Add mass to back of head behind ear

Hairline

Eye line

Mouth line

Long, narrow eye

Bridge of nose is long and straight

Bishie Character Designs

The bishie head has a signature look that needs to be locked into place before you draw the features. Here, I've highlighted the construction step in blue so you can see the commonalities in the character designs.

Classic Bishie: Front View

The classic bishie head is an egg shape that has been adjusted so the chin comes to a delicate point.

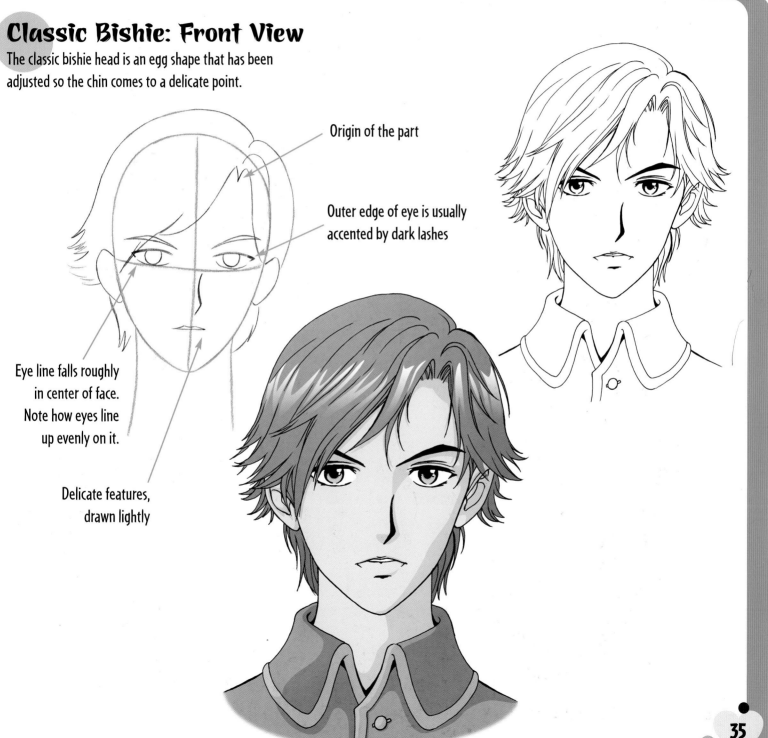

Origin of the part

Outer edge of eye is usually accented by dark lashes

Eye line falls roughly in center of face. Note how eyes line up evenly on it.

Delicate features, drawn lightly

Trendy Bishie: Side View

Here's a snapshot of a classic bishie look—quiet self-reflection. As shown by the unfocused gaze, this stylish bishie is an introspective character.

Huge hair in front and in back

No sharp angles—all subtle contours

See how the eye is recessed from the perimeter of the forehead? A common mistake among beginners is to place the eye too close to the outline of the forehead.

Back to Basics

If your drawing starts to go wrong, go back to the basic construction. Are the eyes aligned evenly? Is the eye line positioned roughly in the middle of the face? Try to take an objective look at your drawing rather than a disapproving one, and you'll see much more easily how to correct it. And besides, give yourself a break—we all make mistakes. If we didn't, it would mean we weren't taking any artistic risks, and therefore we would never grow.

Adult Bishie: 3/4 View

This young adult represents roughly the upper age limit for bishies in the romance genre. There are plenty of adult-looking bishies in other genres, including action and the occult.

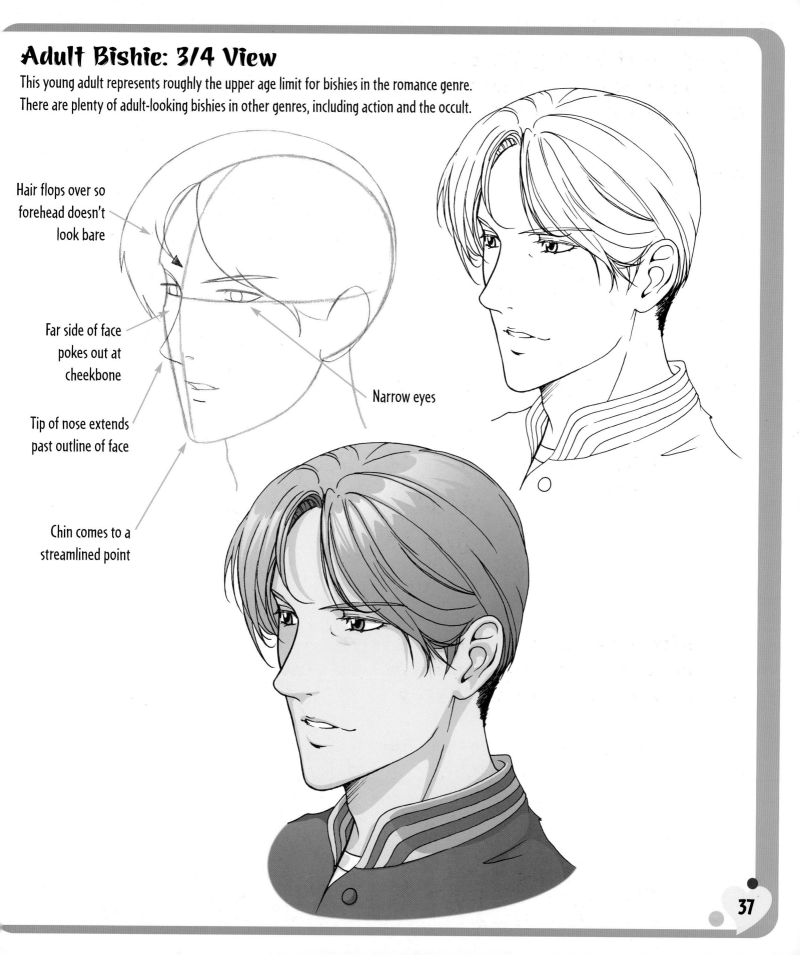

Hair flops over so forehead doesn't look bare

Far side of face pokes out at cheekbone

Tip of nose extends past outline of face

Chin comes to a streamlined point

Narrow eyes

Guys With Glasses

A popular subgenre of bishies, especially in Japan, is bishies with glasses. It's a fashion statement that lends a sophisticated air to the character— a trendy "Euro" look. While glasses give young manga teens a nerdy quality, these bishies are the epitome of cool.

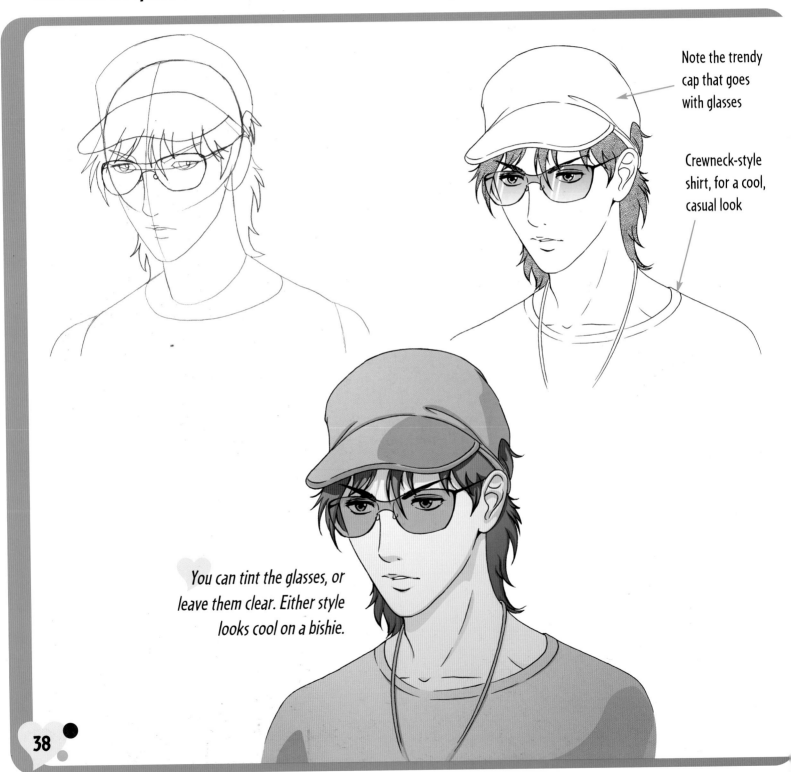

Note the trendy cap that goes with glasses

Crewneck-style shirt, for a cool, casual look

You can tint the glasses, or leave them clear. Either style looks cool on a bishie.

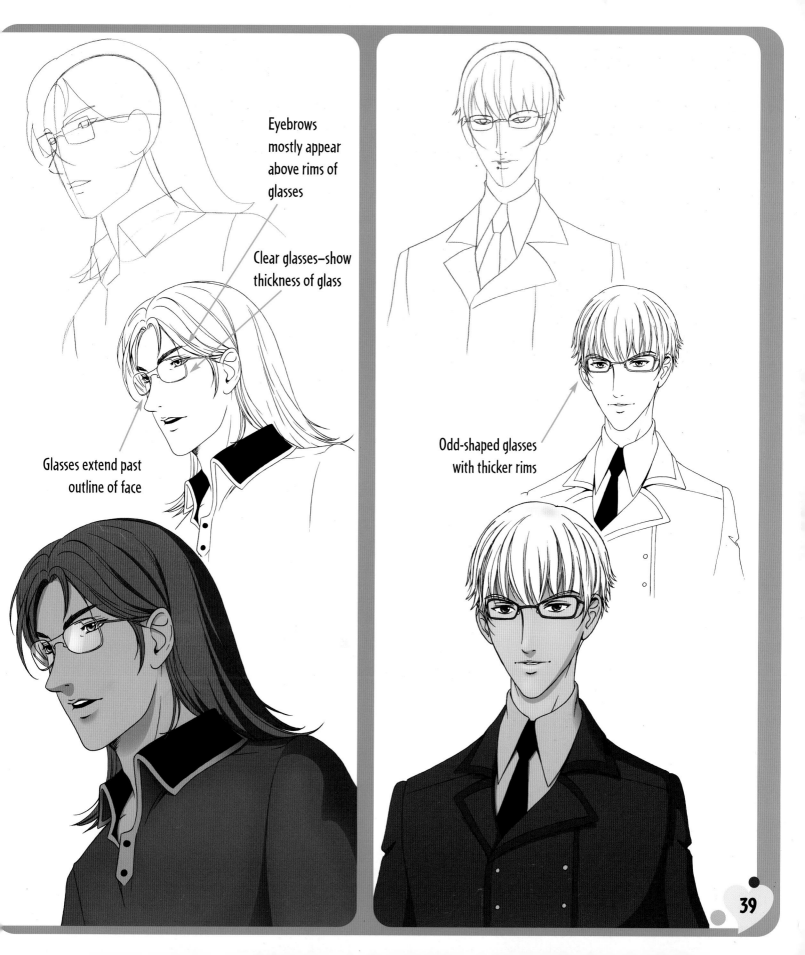

Eyebrows mostly appear above rims of glasses

Clear glasses—show thickness of glass

Glasses extend past outline of face

Odd-shaped glasses with thicker rims

Bishie Bodies

The typical bishie is long, lean and tall. His shoulders are broad, but the rest of his body is thin and lanky. He's got the classic "swimmer's" build.

Standing Poses

It's tempting when drawing a long-legged character to pose him stiffly. But it's the long-legged characters who need to be posed in a relaxed asymmetrical stance. These poses look natural because the legs don't "mirror" each other.

Front View

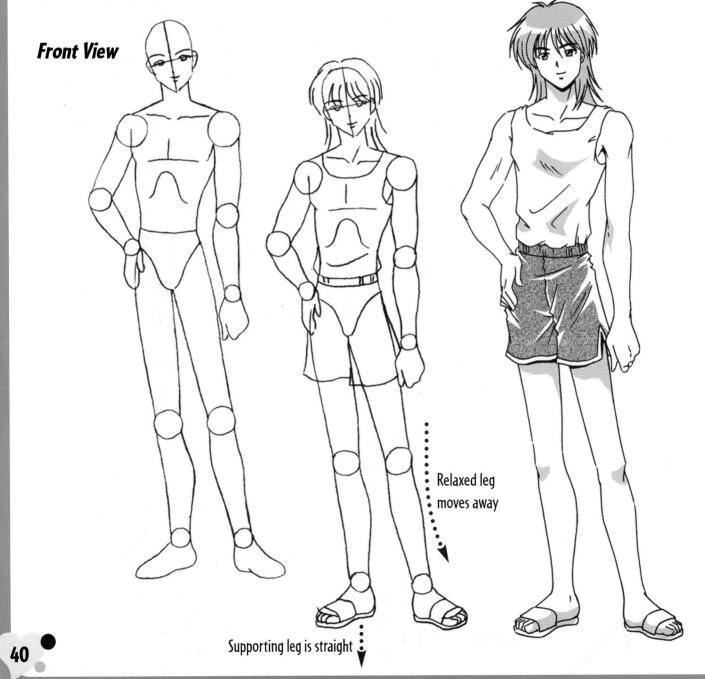

Relaxed leg moves away

Supporting leg is straight

Side View

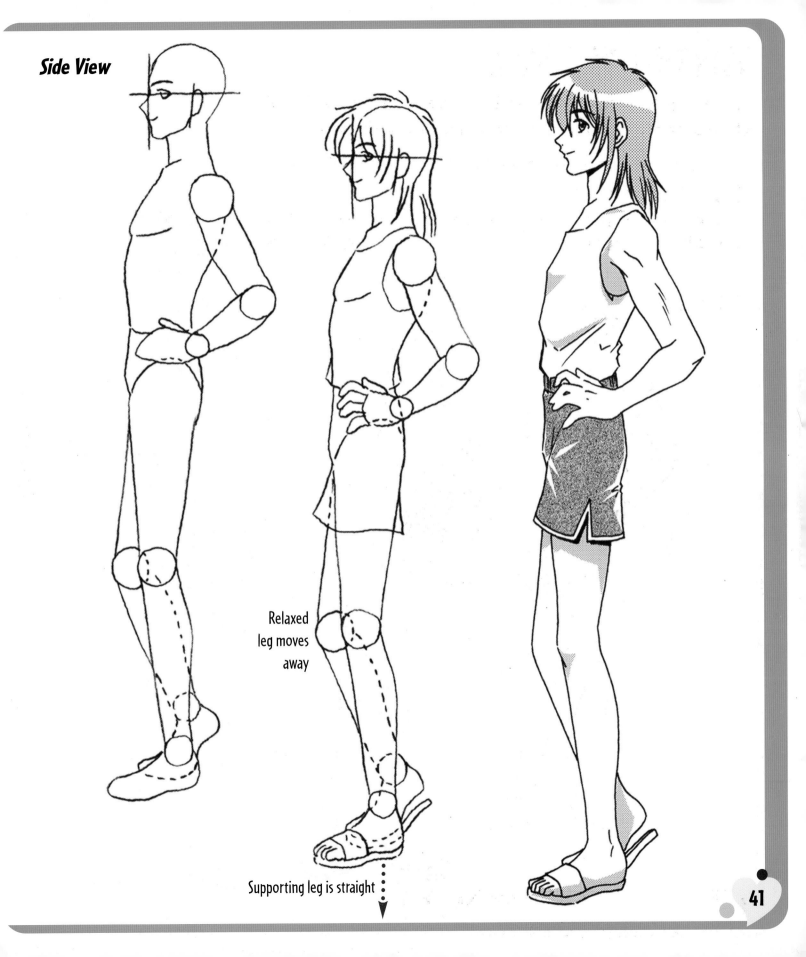

Relaxed
leg moves
away

Supporting leg is straight

Arm Positions

One of the questions that puzzle beginning artists when drawing a standing pose is "What am I going to do with the arms?" The arms often frustrate beginners who get too ambitious. They give the character a sandwich to hold, or a ball to toss in the air.

While that's okay, be careful not to make your character look conspicuously busy. It's often better to simply position the arms as if he were waiting for someone while standing in line. It's that simple. He doesn't have to be doing anything specific with his arms or hands.

Fidgeting

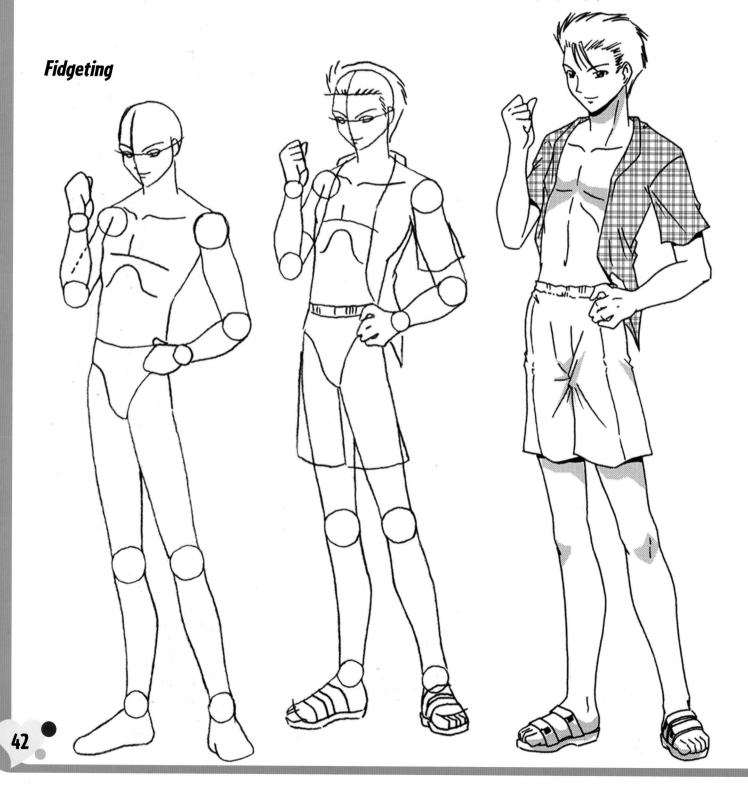

Arms Akimbo

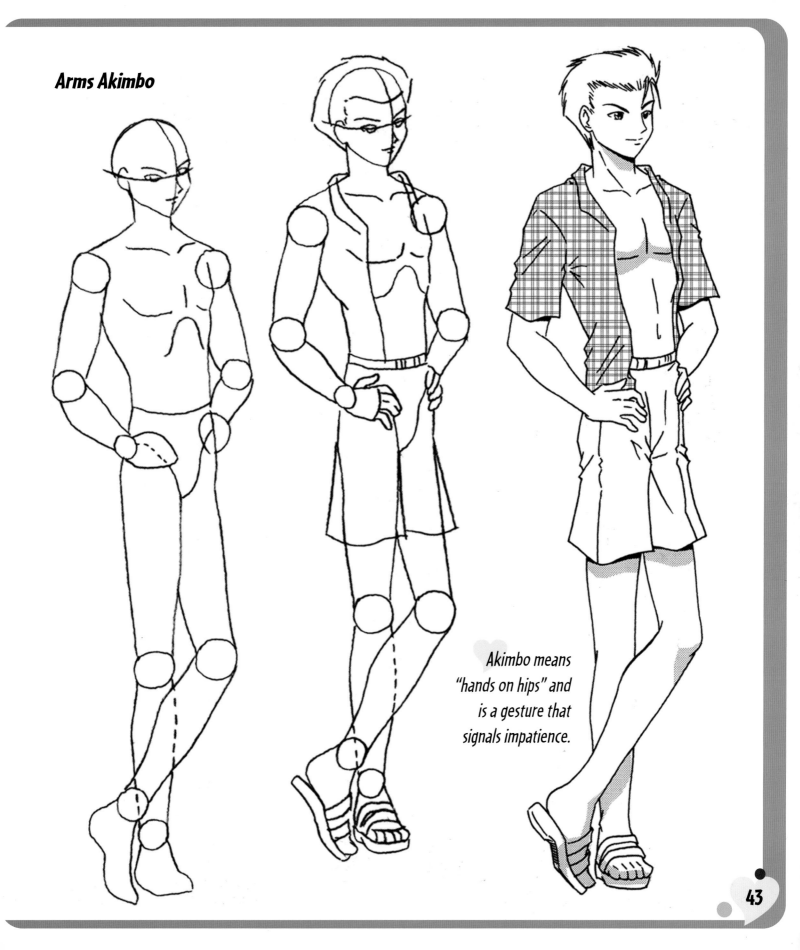

Akimbo means
"hands on hips" and
is a gesture that
signals impatience.

Body Angles

Just like the head, the body can be drawn at extreme angles, although this takes a little more concentration and is used less frequently.

Using "up" and "down" angles creates a definite point of view on the reader's part and assists in the storytelling.

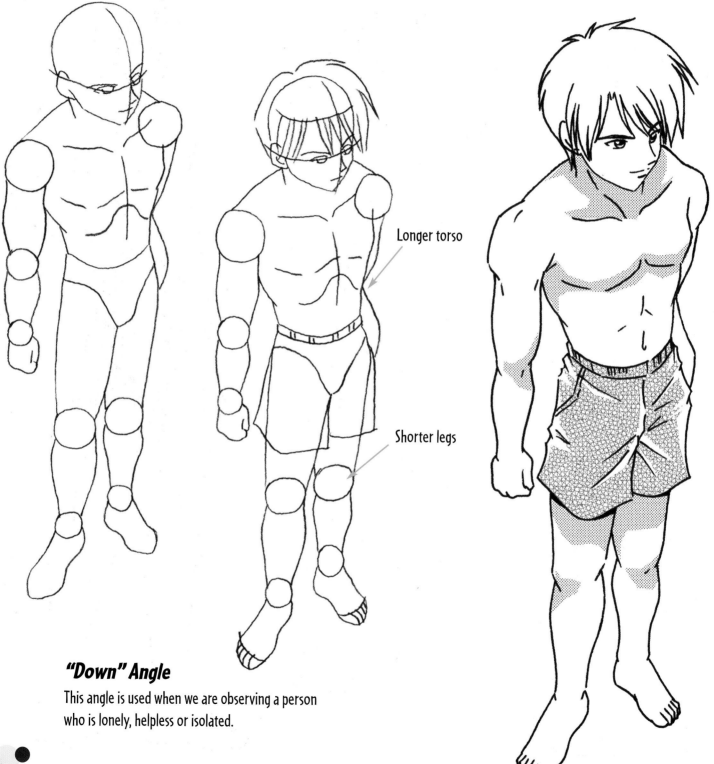

Longer torso

Shorter legs

"Down" Angle

This angle is used when we are observing a person who is lonely, helpless or isolated.

"Up" Angle

Draw characters who are strong, impressive or confident at this angle.

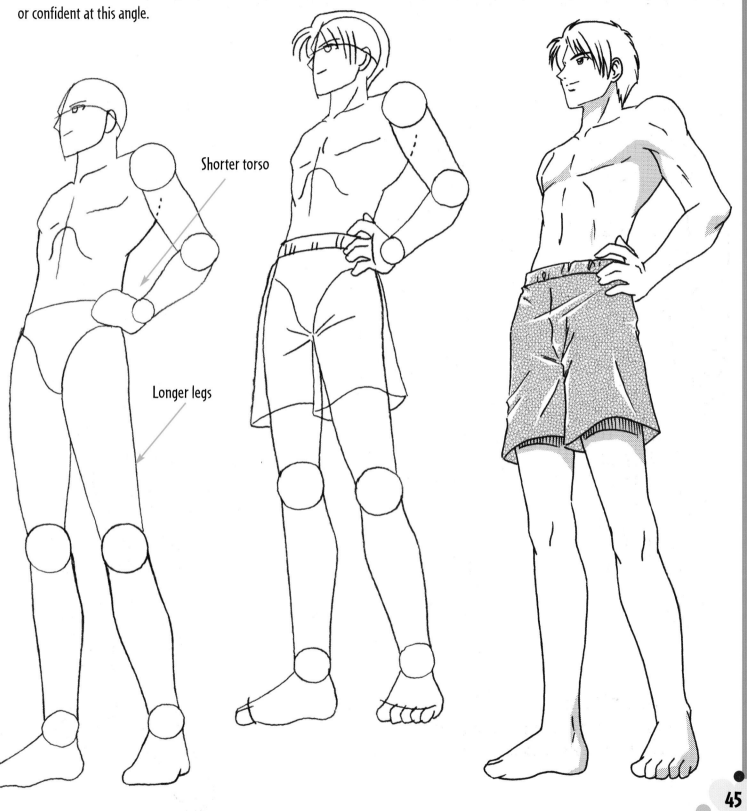

Shorter torso

Longer legs

Bishies in Motion

The bishie always walks with an air of cool confidence. And as he goes past, all the girls try to work up the courage to talk to him!

The Walk: Front View

When we draw a girl walking toward us, her rear leg crosses behind the front one so that it's partially hidden. It's a feminine style. For boys, we keep the legs slightly apart at all times.

Draw him with a relaxed posture bent slightly at the waist. No chest-out proud pose. He's not out to save the world, just to meet girls.

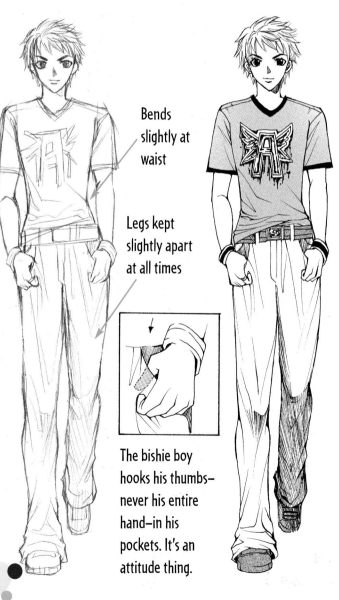

Bends slightly at waist

Legs kept slightly apart at all times

The bishie boy hooks his thumbs—never his entire hand—in his pockets. It's an attitude thing.

The Walk: Side View

It's especially easy to draw his side-view walk, because the arms remain in this same position no matter what the legs are doing.

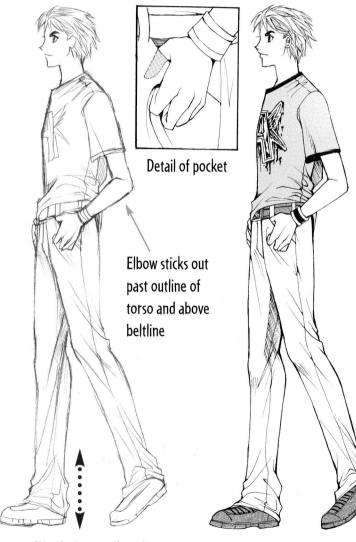

Detail of pocket

Elbow sticks out past outline of torso and above beltline

Weight-bearing leg aligned with center of body

Fast Run: Front View

The faster the run, the more the character will lean forward into the movement. And this fellow is definitely running fast. There are two ways to make a running character look like he's leaning forward.

The first technique is obvious: Draw him bending at the waist. The second is subtler, but just as important and no less effective: Position his lead low on his shoulders, thereby eliminating his neck.

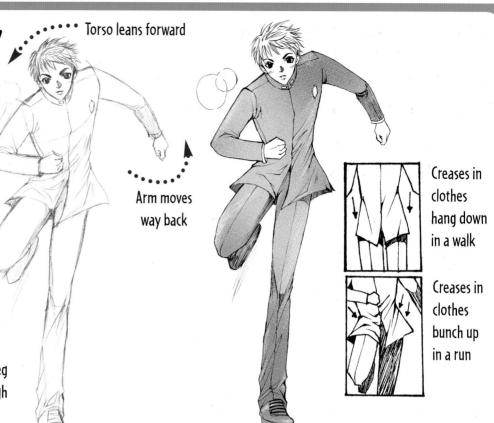

Torso leans forward

Arm moves way back

Lower part of leg tucks behind thigh

Creases in clothes hang down in a walk

Creases in clothes bunch up in a run

Fast Run: Side View

In order to avoid a flat look, twist the character's body—in other words, "corkscrew" the torso as he runs. It has the effect of turning him from a flat side view into a three-dimensional 3/4 view, and it makes him look like he's really digging into the action.

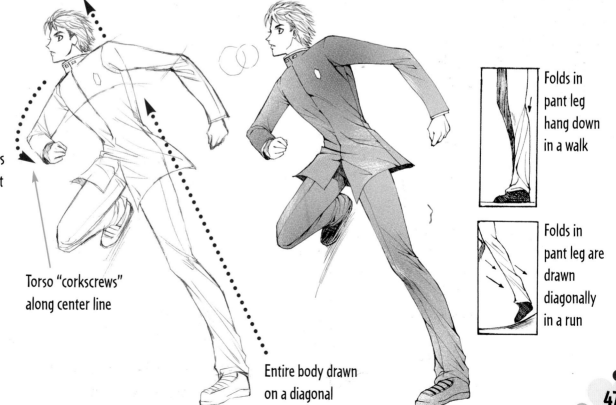

Torso "corkscrews" along center line

Entire body drawn on a diagonal

Folds in pant leg hang down in a walk

Folds in pant leg are drawn diagonally in a run

Bishie Poses

Here are a couple of bishie boy characters in full-body shots and in different poses. As you pose them, notice the attitude shared by almost all bishies: "restrained cool." No, they never get charged up about anything.

They are introverts, and their body language contributes to their brooding, mysterious personae. There's always a distant look in their eyes that makes girls want to conquer them. But alas, it can't be done.

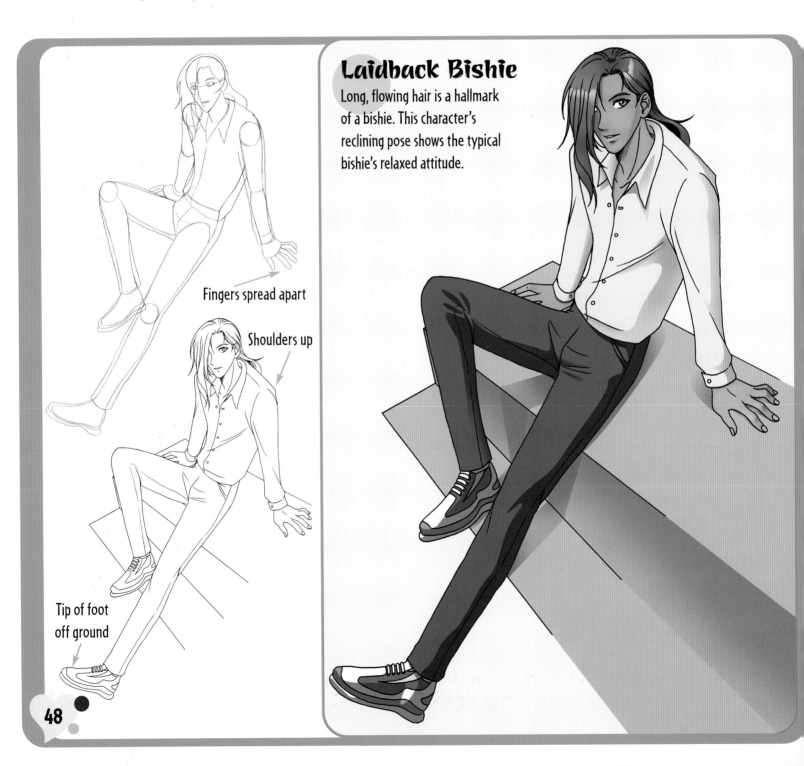

Fingers spread apart

Shoulders up

Tip of foot off ground

Laidback Bishie

Long, flowing hair is a hallmark of a bishie. This character's reclining pose shows the typical bishie's relaxed attitude.

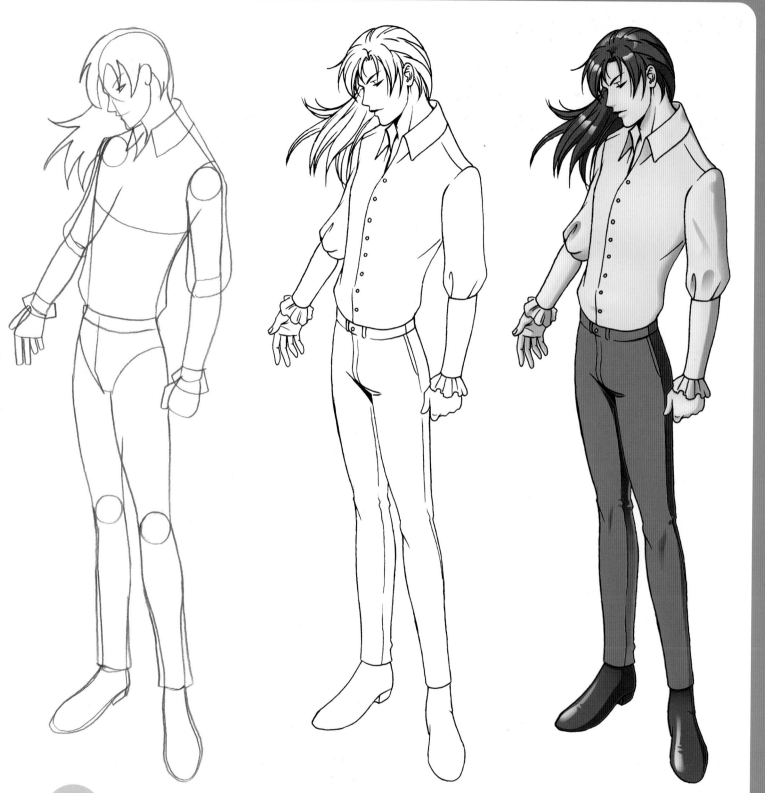

Romantic Bishie

Bishies often wear semi-Victorian clothing. The flowing shirts and tight-fitting pants, combined with the bishie's flowing hair and smoldering eyes, drive the girls wild!

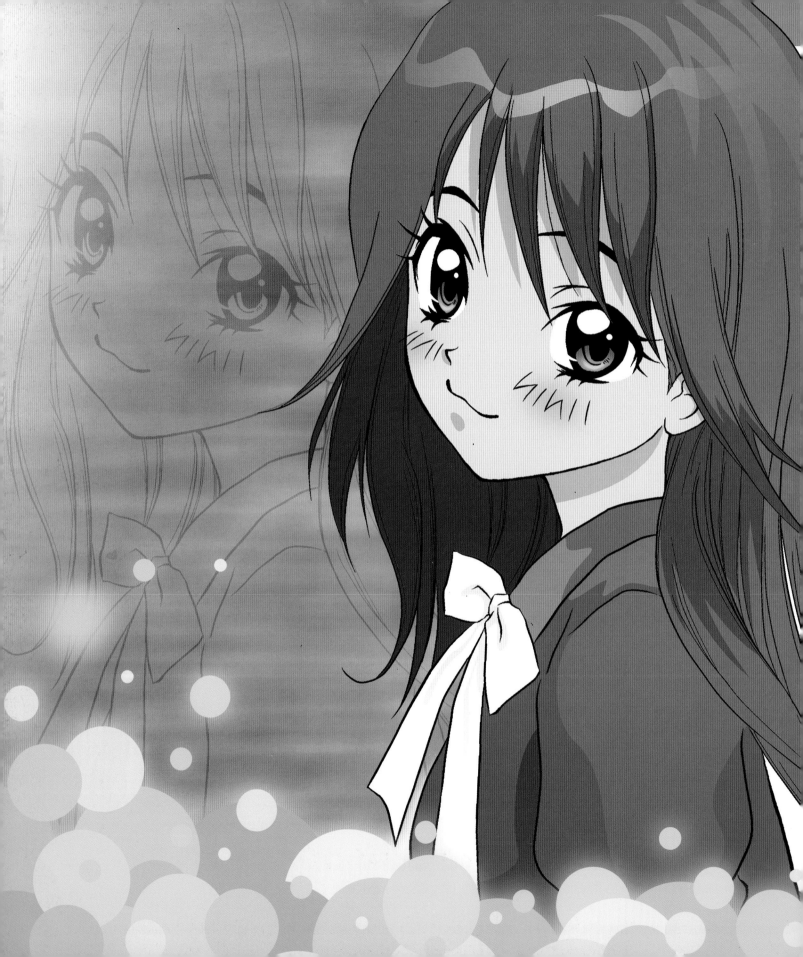

Drawing Fabulous Manga Eyes

Manga characters, especially in the romance genre, are known for their sparkling eyes. You can draw any type of eyes for your character that you want to, but these are tried-and-true designs that you can use as springboards for your creations. After a detailed look at eyes in this chapter, we combine them with the other features to show you how to create expressions that pop off the page.

Girls' Eyes

In manga, teen girls get to have the most glamorous eyes of any characters. The eyes shown here have been taken to the max—with bright "shines" and lots of shading and sparkles. If you want to simplify them, just eliminate the gray areas by turning them solid black. But remember to leave the shines!

Bubbly

Bubbly eyes have round pupils. The eyelids rise up, off the eyes, and the eyebrows are placed high.

Introspective

Introspective eyes are huge, with very little white around the irises. The eyelids droop at a diagonal.

Hint

Most often, and as a good general rule of thumb, two eye shines should be drawn in opposite corners of the eye, diagonal to each other. This placement is very effective.

Wild

These eyes have tiny pupils and eyelashes that tilt up sharply at the ends!

Concerned

When you droop the upper eyelids severely, the character will look concerned.

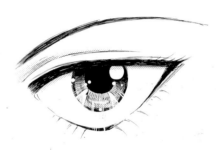

Seductive

The upper eyelids drop down over the pupils for an alluring expression.

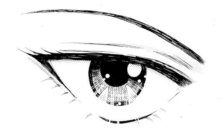

Thoughtful

Lower the bottom eyelid and leave a good amount of white around the iris.

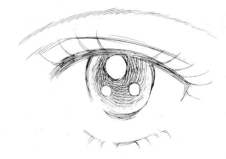

Eyelid Creases

Note that the upper eyelid is always drawn the thickest and darkest.
But most important, just above the eyelid there is a light crease.
Without that, the eye would appear flat and have no depth.

Boys' Eyes

It may seem surprising, but most manga teenage boys do not have thick eyebrows. A few do, but they are in the minority, and I personally think it's an unappealing look. For the most part, boys' eyebrows are drawn much closer to the eyes than females', which are always drawn in a high, arching curve.

Classic

This is the standard look for boys' eyes: big and dark without a lot of variation. You can't go wrong with this style.

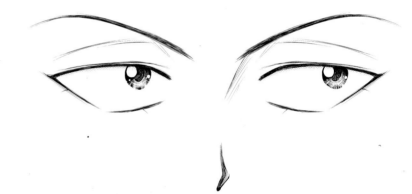

Sarcastic or Cynical

Beady eyes always connote a negative thought or a negative character.

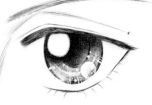

Sensitive

The more sensitive a character, the larger the eyes.

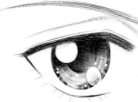

The Eye in Profile

When drawing the eye in profile, you've got to completely change the shape of the pupil/iris. It's no longer a circle at all—or even close to it. Instead, it becomes the slenderest of ovals.

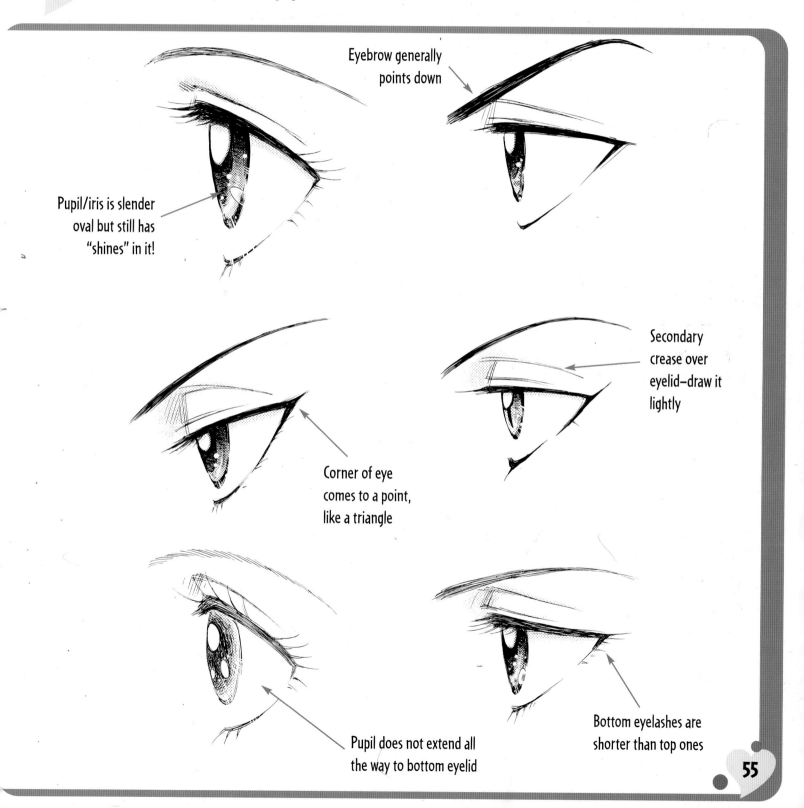

Eyebrow generally points down

Pupil/iris is slender oval but still has "shines" in it!

Secondary crease over eyelid—draw it lightly

Corner of eye comes to a point, like a triangle

Pupil does not extend all the way to bottom eyelid

Bottom eyelashes are shorter than top ones

And Don't Forget Eyebrows!

The eyebrows are the workhorses of the eyes. They do the heavy lifting, using their muscles (yes, the eyebrows really have muscles!) to form a shape that will convey a strong expression. The eyebrows can mirror the shape of the eye or move in the opposite direction. Manga characters are famous for their emotionalism, so it's no coincidence that they have the longest eyebrows in all genres of comics.

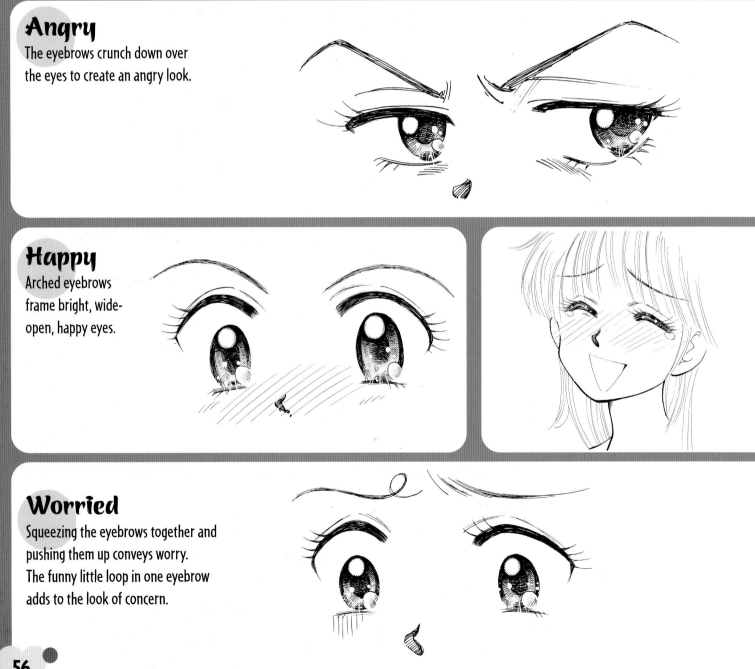

Angry
The eyebrows crunch down over the eyes to create an angry look.

Happy
Arched eyebrows frame bright, wide-open, happy eyes.

Worried
Squeezing the eyebrows together and pushing them up conveys worry. The funny little loop in one eyebrow adds to the look of concern.

Furious

Eyebrows drawn at an extreme angle add to this character's look of fury. Compare these eyes to the merely angry ones on the previous page.

Stunned

Combining classic arched eyebrows with very small pupils shows the character's disbelief.

Melancholy

Horizontal eyebrows with almost no arch create a melancholy look.

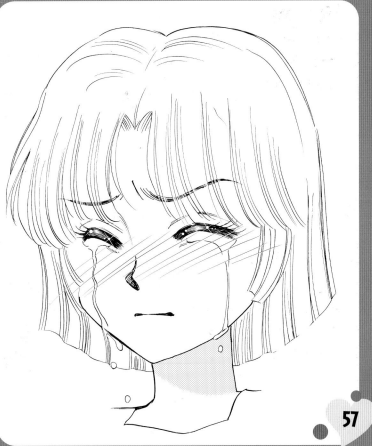

Expression Models

Now, we could just show you a bunch of cool-looking expressions, but you should be able to draw the character that will be making those expressions first. Therefore, we're going to introduce Miyoko—our cartoon model—and show you how to draw her in a step-by-step manner first. Then Miyoko and her friends will go through a series of expressions for us. Notice how the eyes work in tandem with the rest of the body.

Front View

Our model Miyoko is a classic, pretty "droopy-eyed" shojo character. Here she is in a simple front view with a small smile that gives her a pleased, content look.

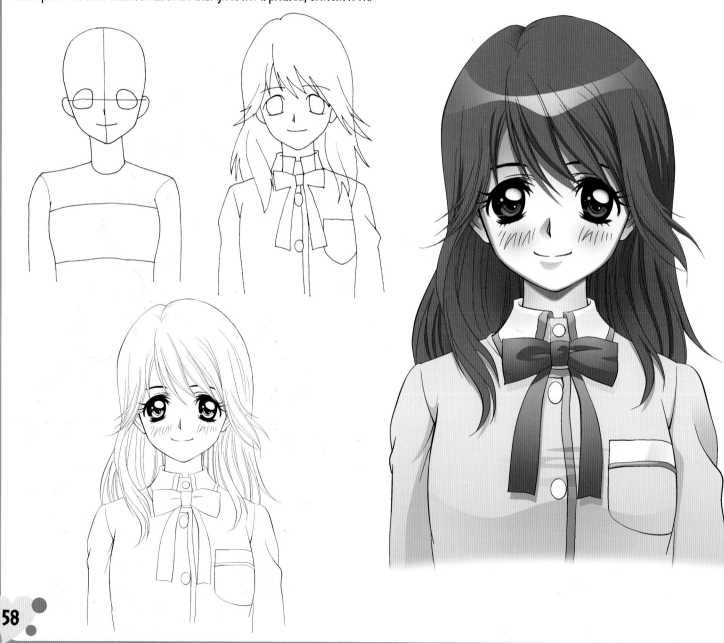

3/4 View

Here is Miyoko again with the same expression as in the front view, but turned slightly to the left. Notice how the shapes of the eyes change as she turns.

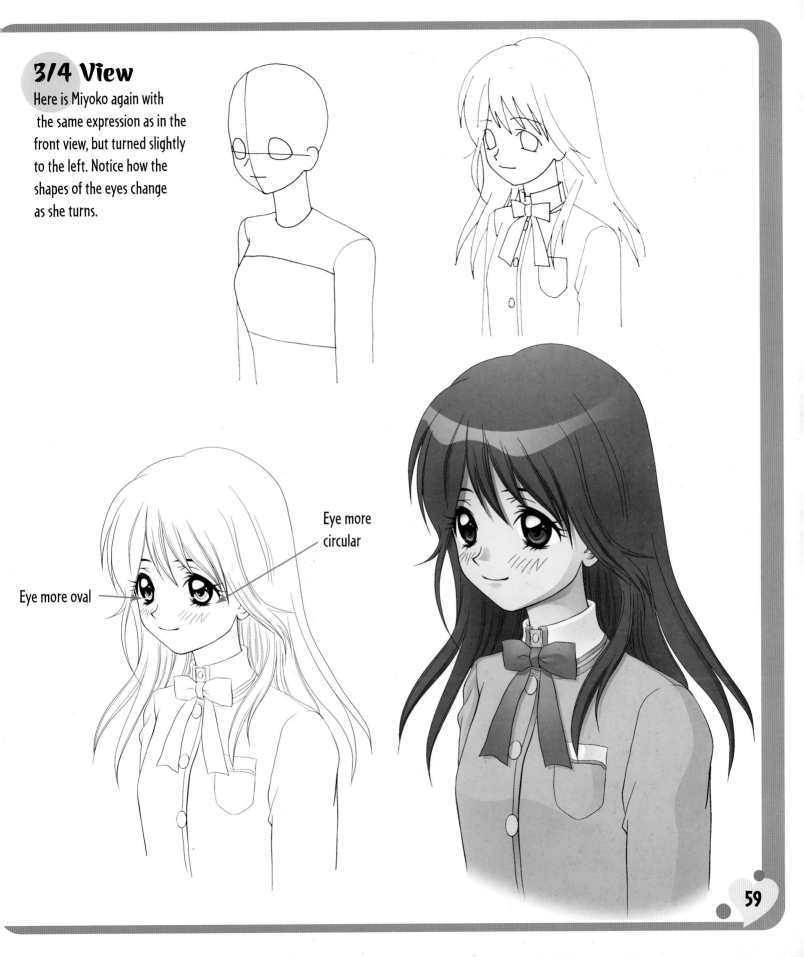

Eye more circular

Eye more oval

Changing the Angles

Here's a good exercise: When you reach a comfort level in drawing a particular character you like, whether you've invented her or gotten her from this book, try drawing her in a variety of poses using the same expression. Once you can do that successfully and consistently, you have moved past the beginner and intermediate levels and are headed toward the advanced levels of comic art.

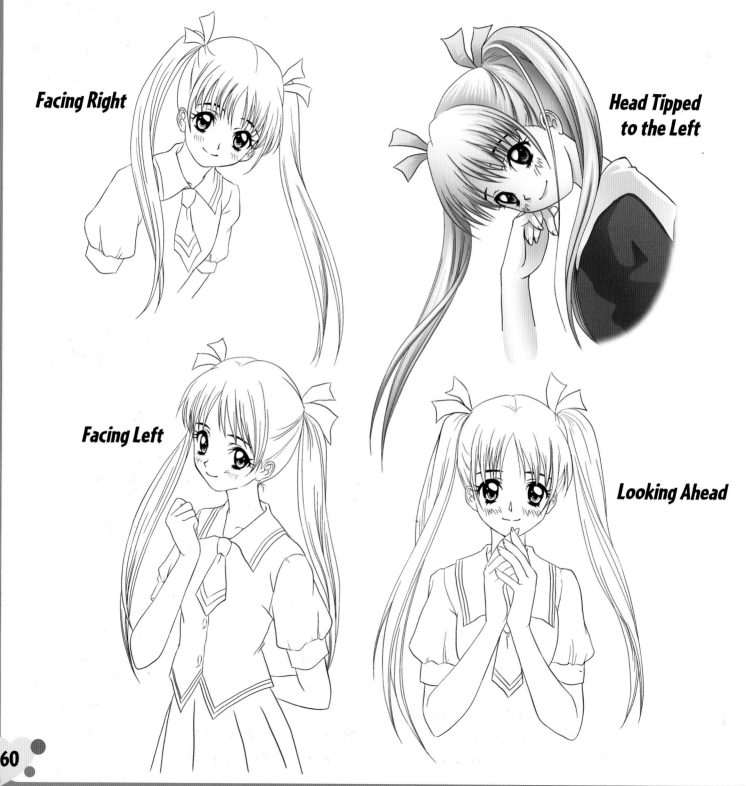

Facing Right

Head Tipped to the Left

Facing Left

Looking Ahead

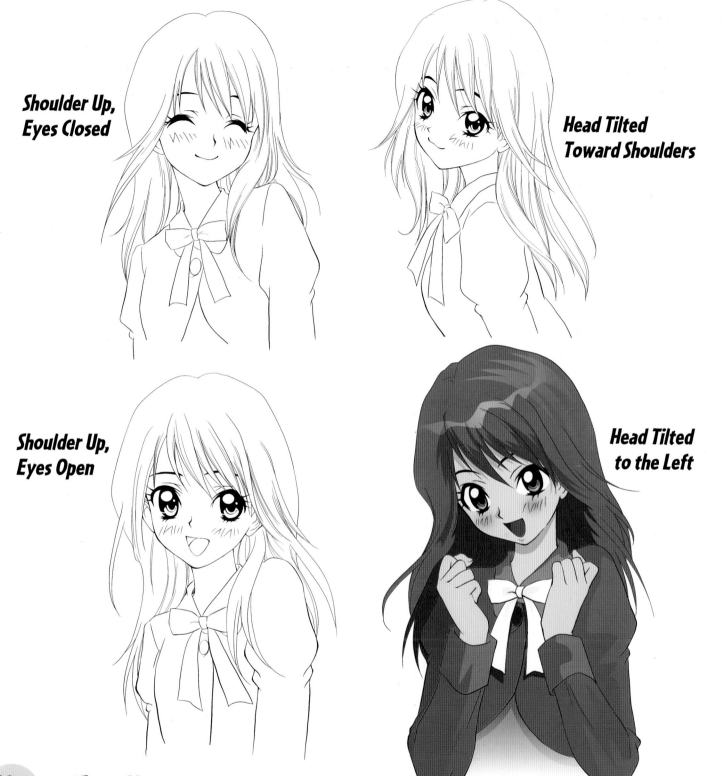

Shoulder Up, Eyes Closed

Head Tilted Toward Shoulders

Shoulder Up, Eyes Open

Head Tilted to the Left

Happy Emotions

Is there only one way to draw someone smiling? According to some drawing books, the answer is "yes." But I think it's safe to say that you and I wouldn't agree with that. So let's see a few different poses for a happy girl.

Do you notice anything interesting going on here? OK, I'll give you a hint: The tilt of the head and shoulders conveys as much emotion as the expression on the face. Take a look!

Boo-Hoo!

Readers love to see their favorite characters in the grip of deep emotions. It allows them to empathize with them.

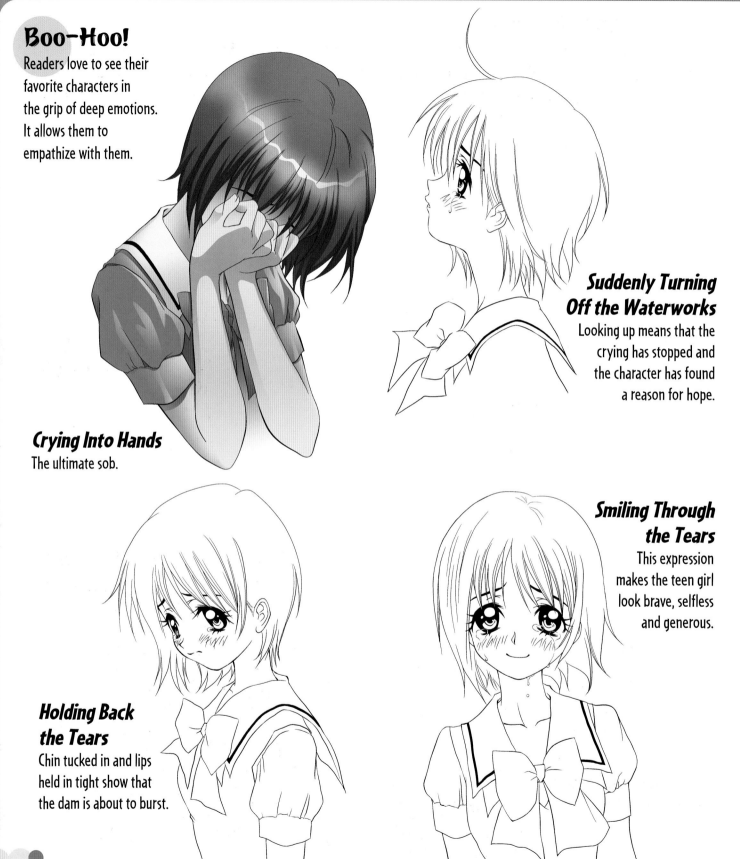

Crying Into Hands

The ultimate sob.

Suddenly Turning Off the Waterworks

Looking up means that the crying has stopped and the character has found a reason for hope.

Smiling Through the Tears

This expression makes the teen girl look brave, selfless and generous.

Holding Back the Tears

Chin tucked in and lips held in tight show that the dam is about to burst.

Surprised and Stunned

Stunned eyes share a common trait, no matter what the rest of the face is doing: The pupils swim in the middle of the whites of the eyes. And don't forget to draw those great blush lines across the cheeks. Stunned expressions lend themselves naturally to comedic interpretations. However, the broader you go, the more you lose the attractiveness of the character. In order to keep her pretty, make the expressions somewhat restrained—even if it is hard for you manga maniacs to restrain yourselves!

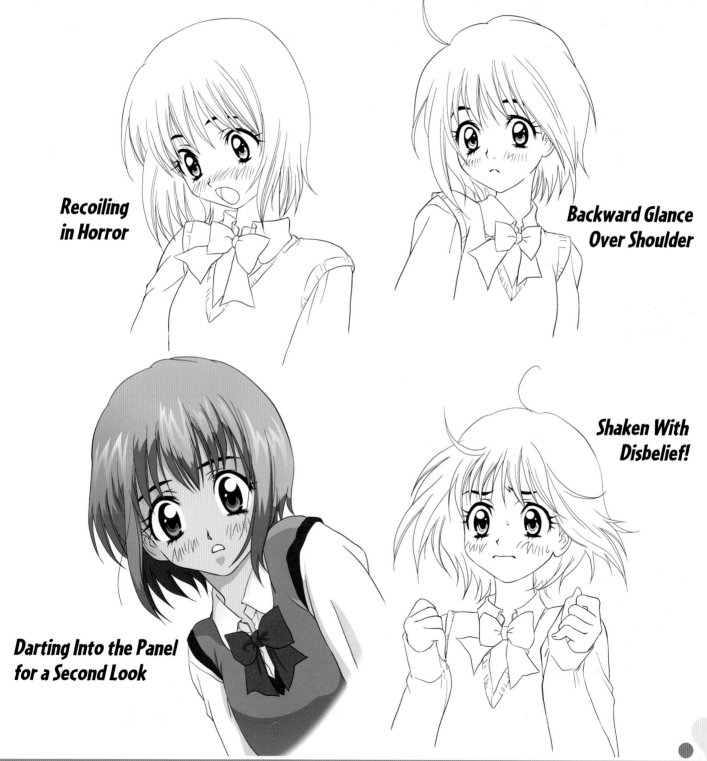

Recoiling in Horror

Backward Glance Over Shoulder

Shaken With Disbelief!

Darting Into the Panel for a Second Look

Coy, Shy and Modest

This playful look requires a narrowing or closing of the eyes, and often a slight tilt of the head. Notice how she gestures with her hands. They cover the mouth slightly as if to hide the embarrassment of a smile. Can you tell what is being exaggerated in this charming expression? It's the eyelashes. Yes, you can actually make them longer to suit a particular emotion.

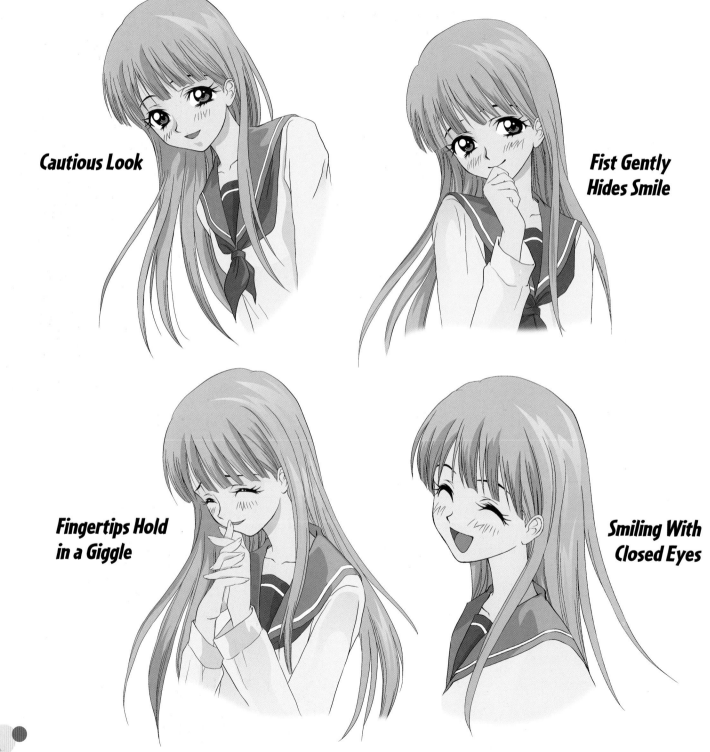

Cautious Look

Fist Gently Hides Smile

Fingertips Hold in a Giggle

Smiling With Closed Eyes

64

Bishie Expressions

Here's a condensed spectrum of bishie expressions from angry to happy. Most bishie attitudes are slightly restrained—even the emotionally charged ones. It's consistent with the style of character.

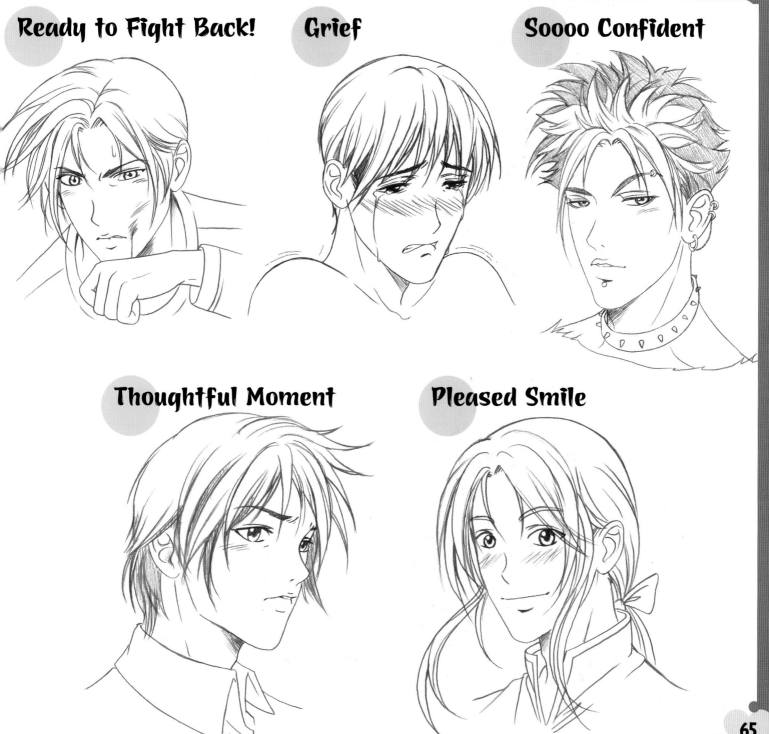

Ready to Fight Back!

Grief

Soooo Confident

Thoughtful Moment

Pleased Smile

Humorous Expressions—Chibi Style!

Have you ever had a really embarrassing moment where you said something or did something so stupid that all your friends burst out in laughter? Me neither.

But for those characters who have, any extreme emotion can be turned into a humorous moment. Even in the middle of a dramatic moment, if the character experiences a gigantic emotion, he or she may "go chibi"—which means that for a moment, his or her proportions and expressions will become toddlerish and very broad. Readers love these comic moments. Manga is a sturdy genre, and it is able to poke fun at its own characters and bounce back without disrupting the general flow of the scene, while American-style comics cannot.

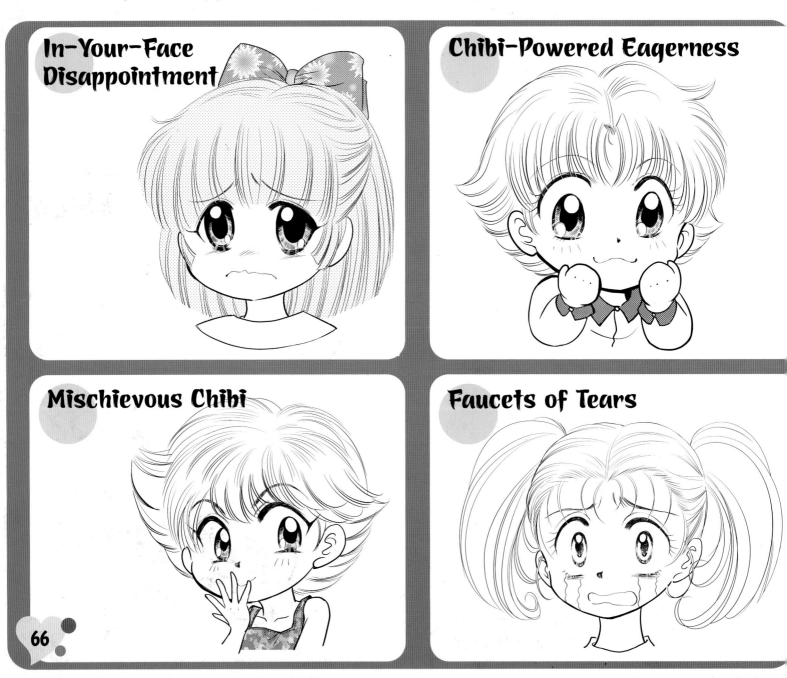

In-Your-Face Disappointment

Chibi-Powered Eagerness

Mischievous Chibi

Faucets of Tears

The Sneaky Thought

Evil glint in the eye

Stunned Into Silence

Surprise streaks—keep them short and spread 'em apart!

Very, Very Bad Indeed

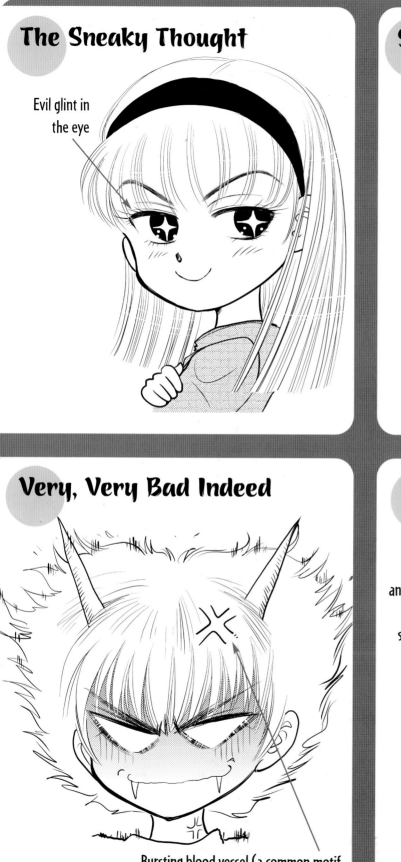

Bursting blood vessel (a common motif for intense chibi moments)

Determination

Blush lines and a droplet of sweat show effort

Costume Design

Now we're going to put our characters in popular schoolgirl and bishie costumes. For the outfits in this chapter, I consulted with a Japanese manga specialist working in Japan, so you know they're authentic. And as you've probably come to expect by now, we're going to show you how to draw them step by step so you'll have no trouble designing your own fabulous costumes.

Girls' Costumes: Classic Sailor Suit

The most popular Japanese public-school uniform is a loose interpretation of a sailor suit. It's a cute, endearing outfit. You can personalize it by adding more frills or buttons, or by designing different types of trims or patterns. Perhaps your collar will be wider and rounder, or triangular instead. None of these changes will sacrifice the authenticity of the look. And it's a good way to make the character your own.

Sailor Outfit: Version 1

In order to glamorize the outfit, everything is lightly exaggerated: boots a little taller, ribbons a little longer, flounces a little frillier. This step-by-step demonstration shows you the common traits of almost every sailor suit. After you make sure your design has these in place, you can work on creatively customizing them.

Schoolgirl Costume Checklist

When designing clothes for manga high school girls, your costumes should:

- Enhance the beauty of the character

- Look like a uniform

- Vary slightly from character to character

- Mirror the personalities of the owner

- Have layers, frills, flounces or pleats

Action line

The "line of action" or "action line" is a sketch line that helps the artist plot the basic thrust of the pose.

70

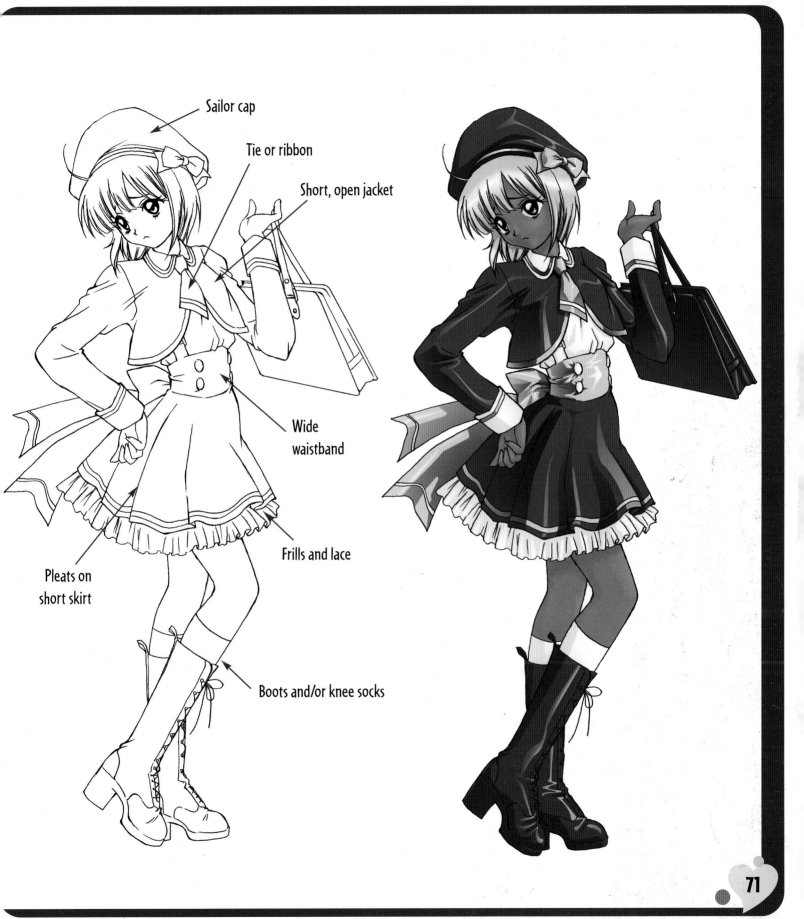

Sailor cap

Tie or ribbon

Short, open jacket

Wide waistband

Frills and lace

Pleats on short skirt

Boots and/or knee socks

Sailor Outfit: Version 2

The sailor-suit outfit is a great costume for high school characters because only schoolgirls wear them. It immediately says to your reader that the story is set amongst students.

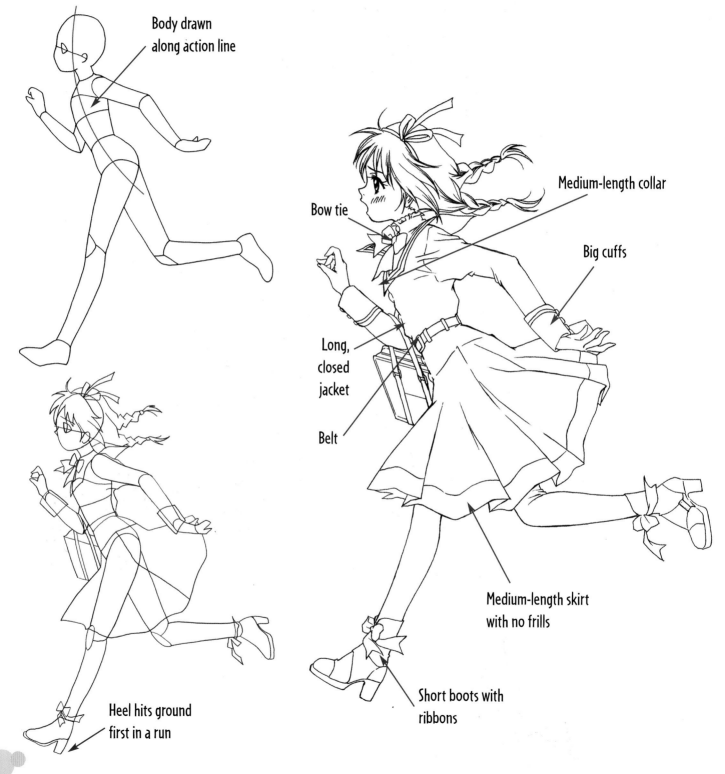

Body drawn along action line

Medium-length collar

Bow tie

Big cuffs

Long, closed jacket

Belt

Medium-length skirt with no frills

Short boots with ribbons

Heel hits ground first in a run

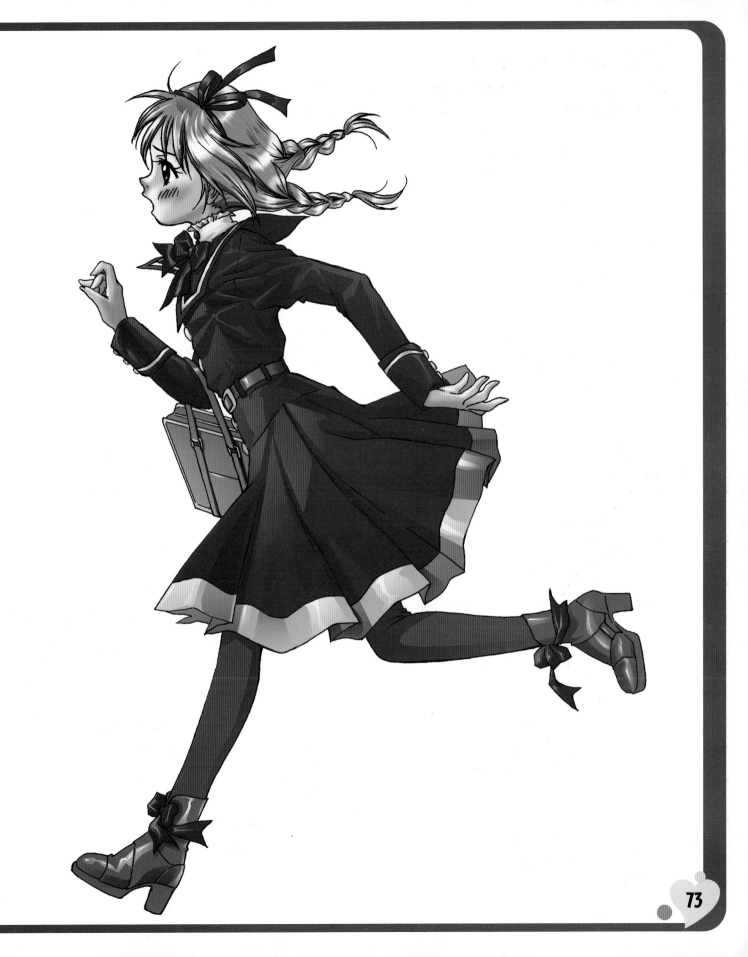

Girls' Private-School Outfits

In private schools, students are freer to wear what they want. They can be trendy and upscale or slightly gothic and intense. It depends on the character. But there's a saying in the creative arts: You've got to like your character. So even if your character is, for example, a loner, you have to create a loner that the readers will find appealing. You don't want to draw one the audience wishes would get lost!

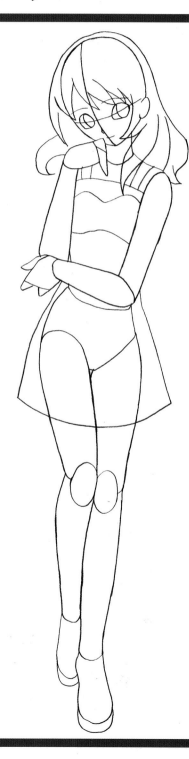

Upscale Outfit

Remember that we talked about tilting the head and employing the shoulders in the section about expressions? See how that comes in handy when we want to give this "daddy's little girl" character a coy look? (You can bet that Daddy paid a lot for this outfit!)

Wide headband

Dainty bracelet

Oversized bow

Frilly "baby doll" dress

Ruffle

Strappy sandals

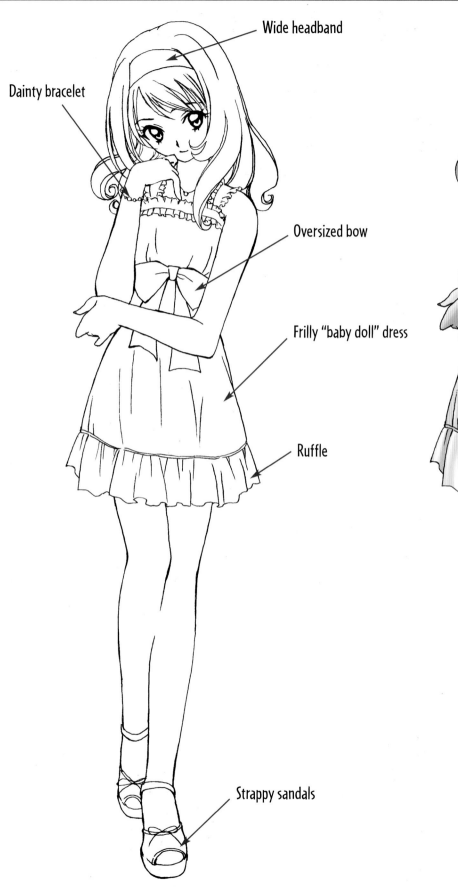
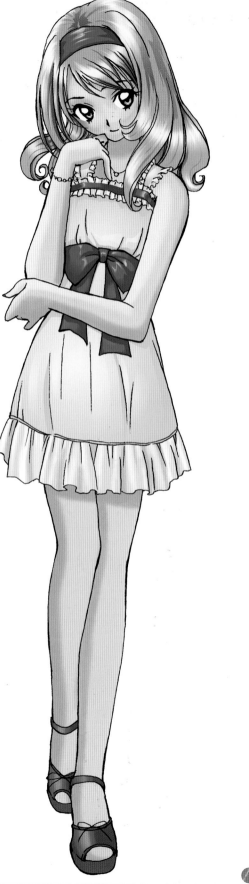

Rebel Teen Outfit

There's always one in the crowd who doesn't go along with the clique–and not because she's uncool or not pretty enough. Maybe it's because she's too cool. She doesn't need to be part of a group of pretentious teens to feel good about herself. Maybe she's a singer in a garage rock band or a gifted graphic artist. Whatever her story is, she's definitely artsy.

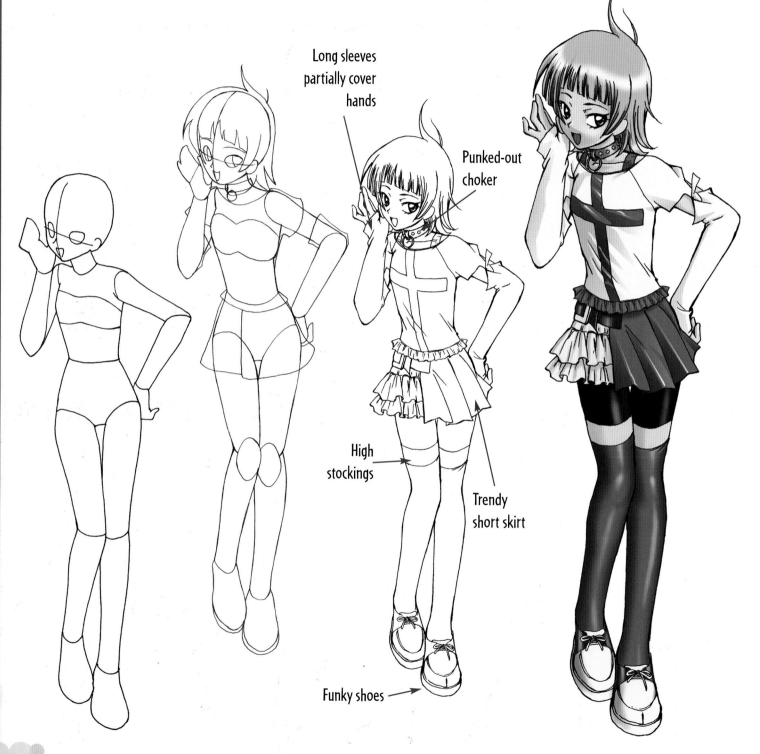

Long sleeves partially cover hands

Punked-out choker

High stockings

Trendy short skirt

Funky shoes

Folds & Wrinkles

Here are some examples of the different ways clothes react to stress. Notice in particular the lines the folds and wrinkles form in each arrangement.

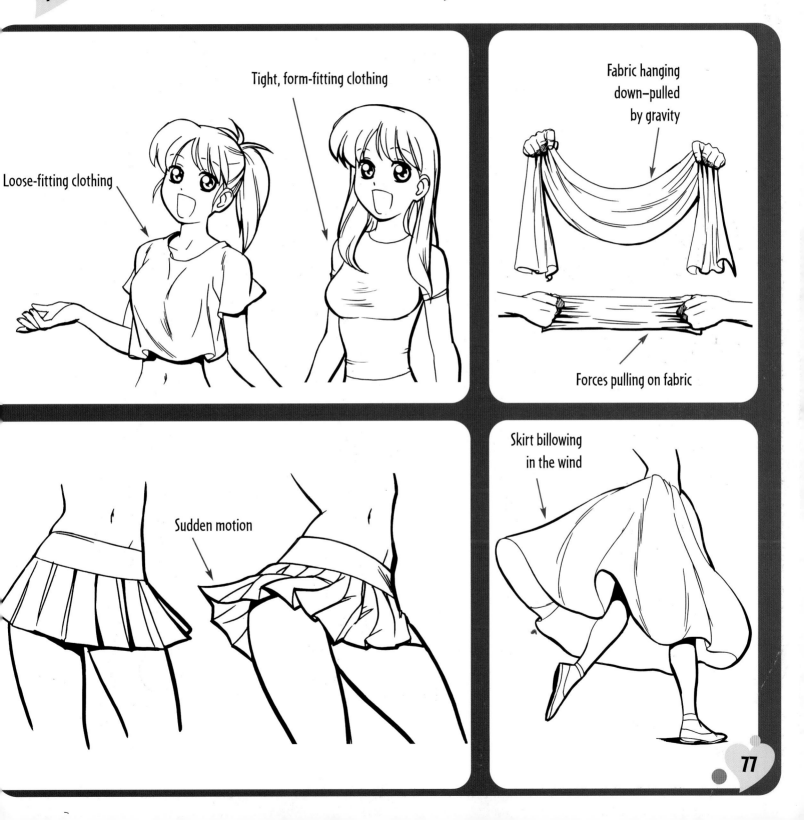

Loose-fitting clothing

Tight, form-fitting clothing

Fabric hanging down–pulled by gravity

Forces pulling on fabric

Sudden motion

Skirt billowing in the wind

Upscale Bishie Costumes

There are two main styles of bishie costume used in the romance genre: casual sports attire and sports jackets, or sometimes Nehru jackets. Either way, the clothes should be stylish and fashionable.

Upscale clothing brings out the mature side of the character and also puts him at a distinct advantage over younger-looking teenage boys—especially when it comes to impressing the girls!

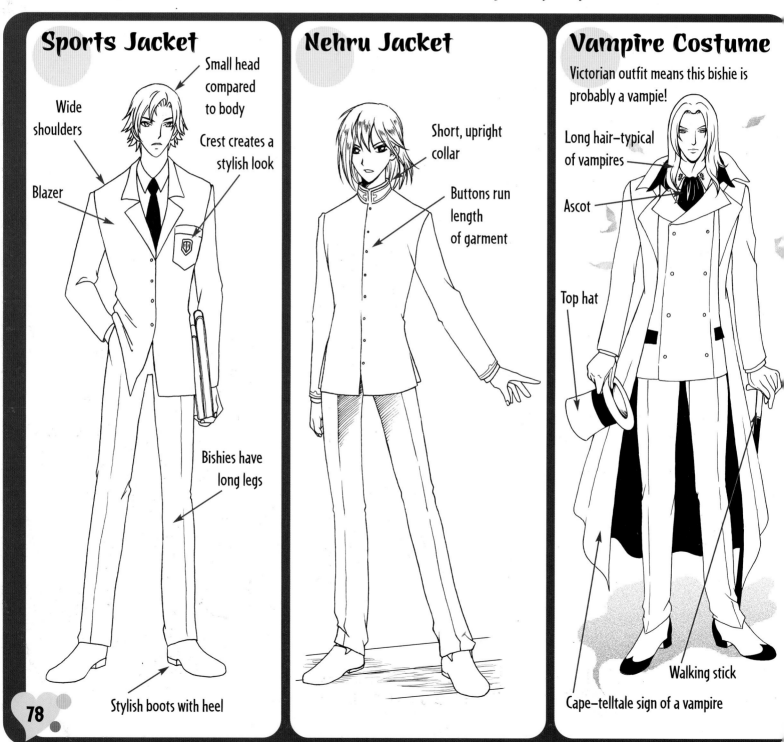

Sports Jacket

- Small head compared to body
- Wide shoulders
- Crest creates a stylish look
- Blazer
- Bishies have long legs
- Stylish boots with heel

Nehru Jacket

- Short, upright collar
- Buttons run length of garment

Vampire Costume

Victorian outfit means this bishie is probably a vampie!

- Long hair—typical of vampires
- Ascot
- Top hat
- Walking stick
- Cape—telltale sign of a vampire

Casual Bishie Outfits

Bishies, by nature, are quasi-rebels. Even in school they sport a casual look that tells the world that they're individuals.

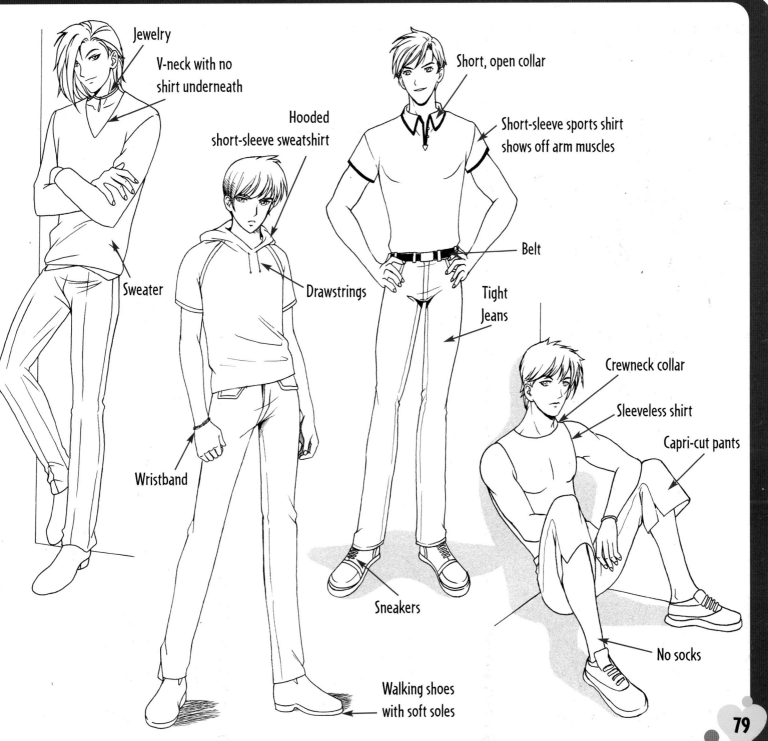

Jewelry

V-neck with no shirt underneath

Hooded short-sleeve sweatshirt

Short, open collar

Short-sleeve sports shirt shows off arm muscles

Sweater

Drawstrings

Belt

Tight Jeans

Crewneck collar

Sleeveless shirt

Capri-cut pants

Wristband

Sneakers

No socks

Walking shoes with soft soles

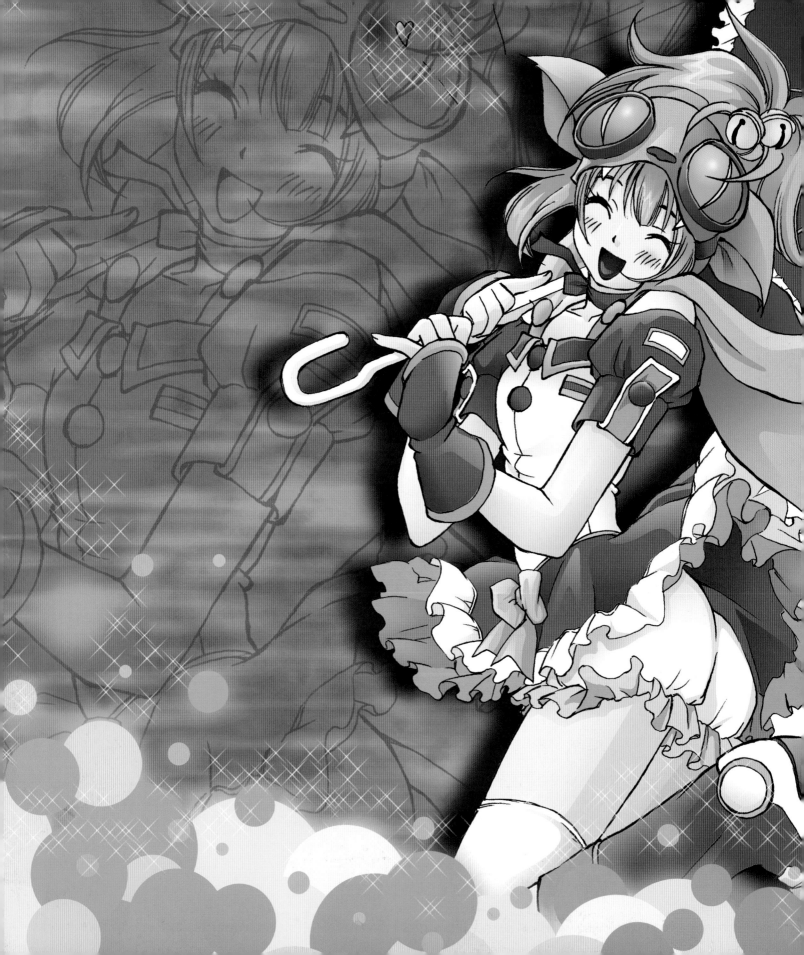

Magical Girls

Magical girls are pretty high school girls who discover they have special powers that transform them into super-glamorous versions of themselves. They can be the supermodel who gets the unattainable guy, a rock star, a beautiful anthro, or anything else a girl might want to be. It's all about wish fulfillment—on a spectacular level. We've already drawn pretty schoolgirls in earlier chapters. Those are the pre-magical girls. This chapter shows them post-transformation.

Classic Magical Girl

Magical girls wear a festival of frills, lace and ribbons. The classic look includes a short dress with long sleeves and lots of layers. Poofy shoulders and fantsay-style hair are almost always checked off on the list.

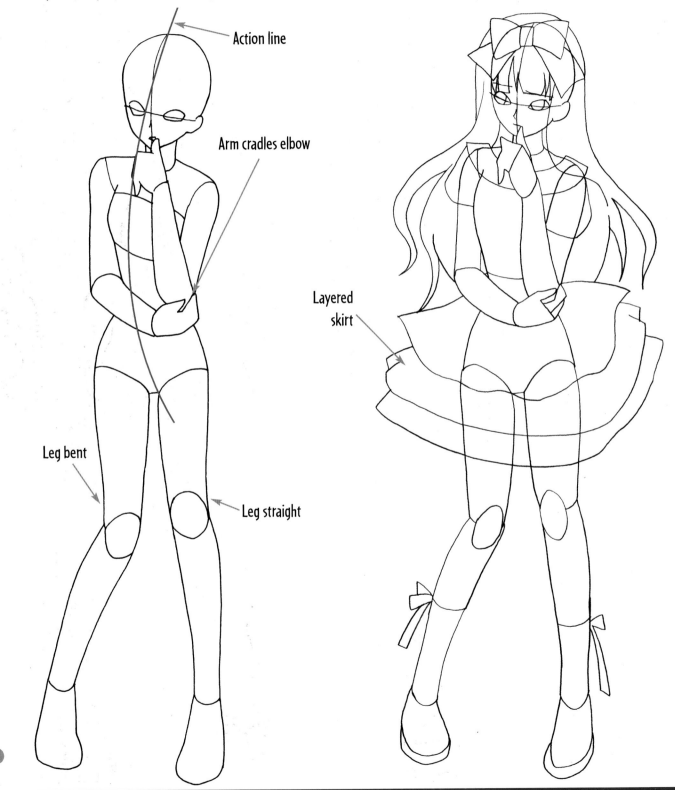

Action line

Arm cradles elbow

Layered skirt

Leg bent

Leg straight

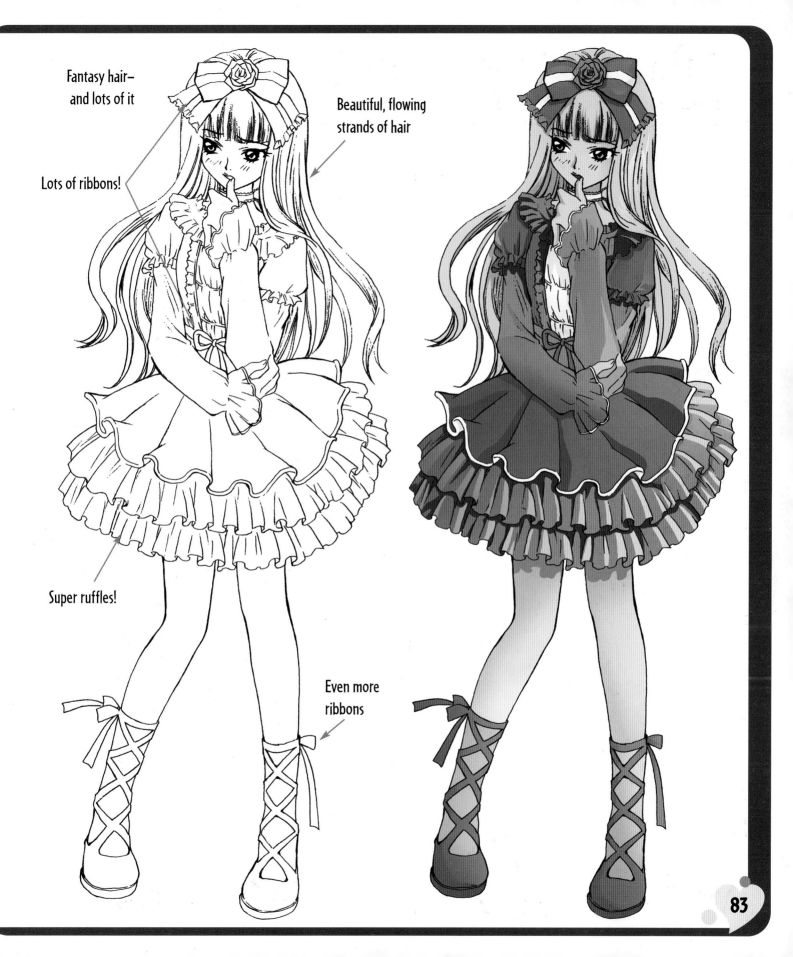

Fantasy hair–
and lots of it

Beautiful, flowing
strands of hair

Lots of ribbons!

Super ruffles!

Even more
ribbons

83

Magical Girl Princess

In this transformation, the girl has become a young princess with a magical locket, perhaps bearing the picture of the boy she loves. Lockets, crystals, rings, bracelets and other trinkets can add some personality and depth to a character.

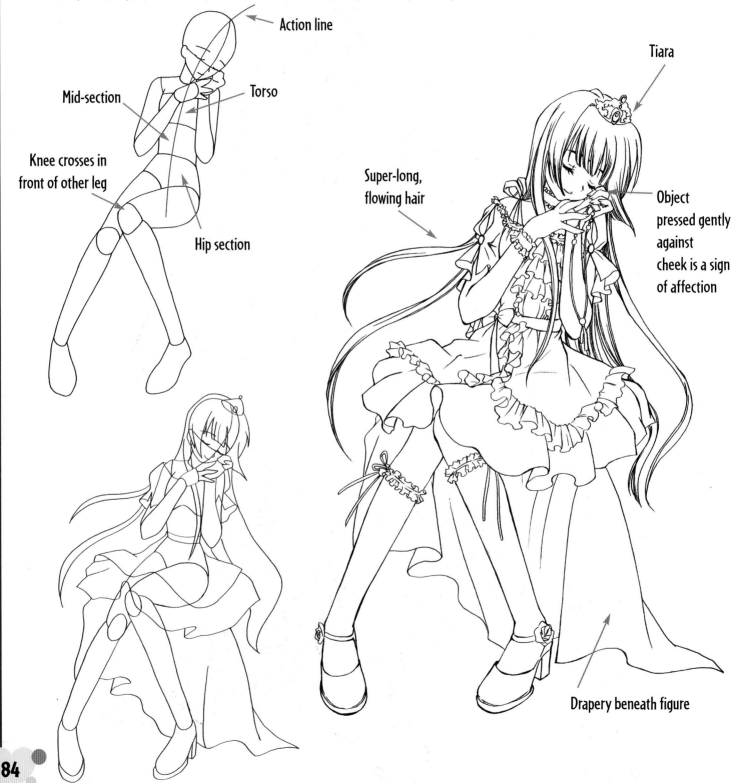

Action line

Tiara

Mid-section

Torso

Super-long, flowing hair

Object pressed gently against cheek is a sign of affection

Knee crosses in front of other leg

Hip section

Drapery beneath figure

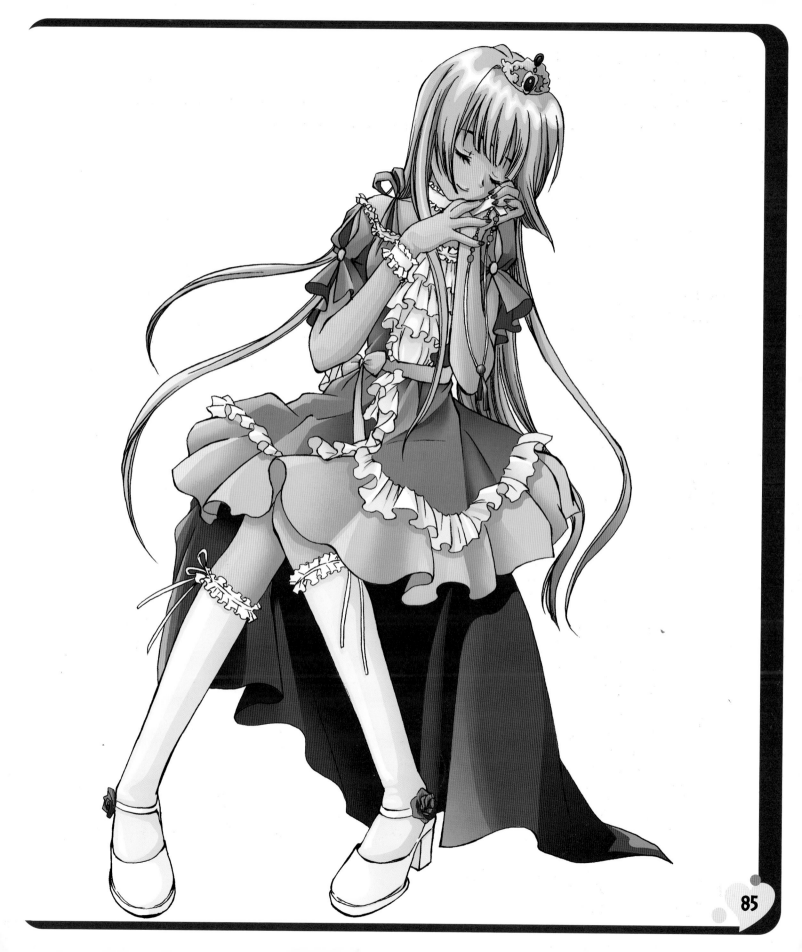

Cat Girl

Magical girls can also be funny, especially if they are silly "anthros"–animal-human combos. This girl's over-the-top outfit and exuberance make her a sweet, humorous character.

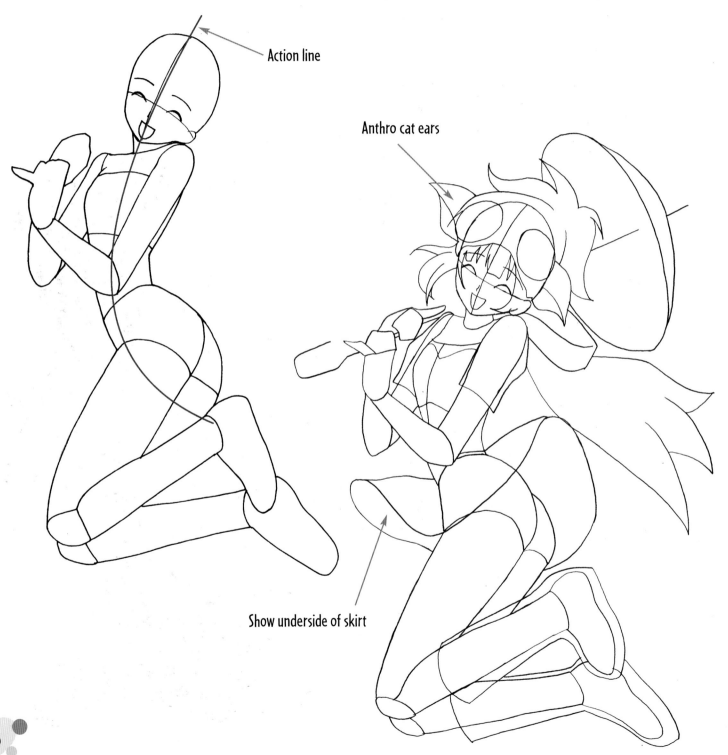

Action line

Anthro cat ears

Show underside of skirt

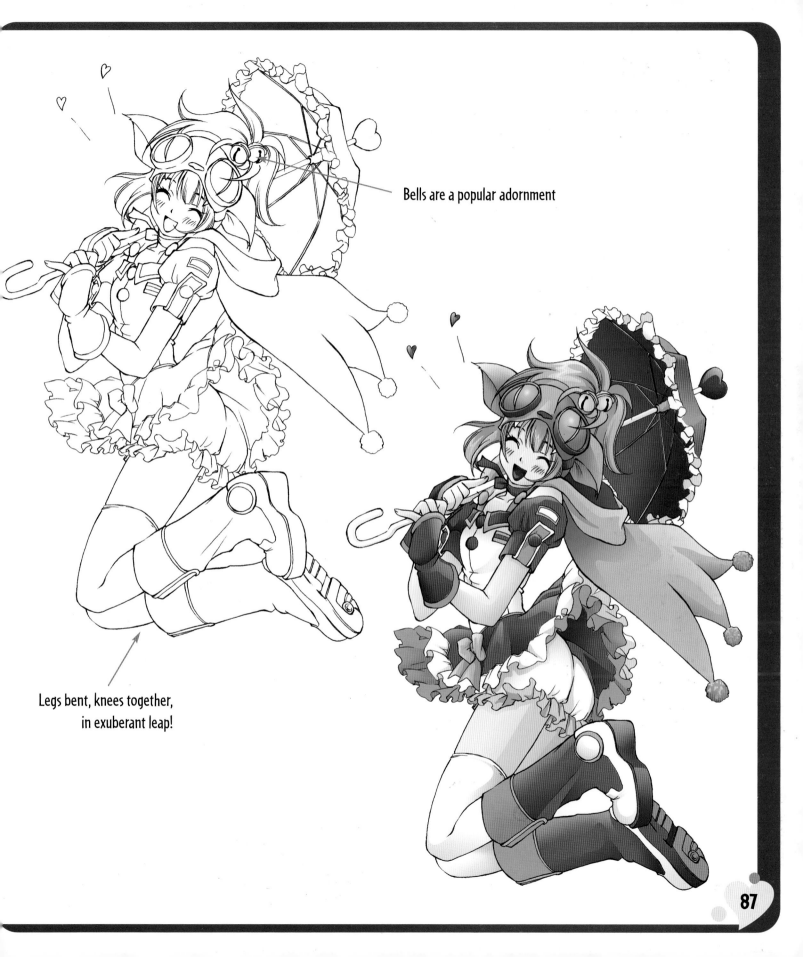

Bells are a popular adornment

Legs bent, knees together,
in exuberant leap!

Magical Girls & Their Magical Buddies!

Magical girls often have ultra-adorable little sidekicks. These funny, tiny creatures make irresistible pets. But oh boy, do they cause trouble, the little mischief-makers! They're so cute, though, that you can't stay mad at them for long.

These critters should be drawn with huge heads and round, pudgy bodies–the kind you just want to squeeze and hug. Spread their eyes far apart to maximize their cuteness. Is "cuteness" a real art term? It is when drawing manga fantasy creatures!

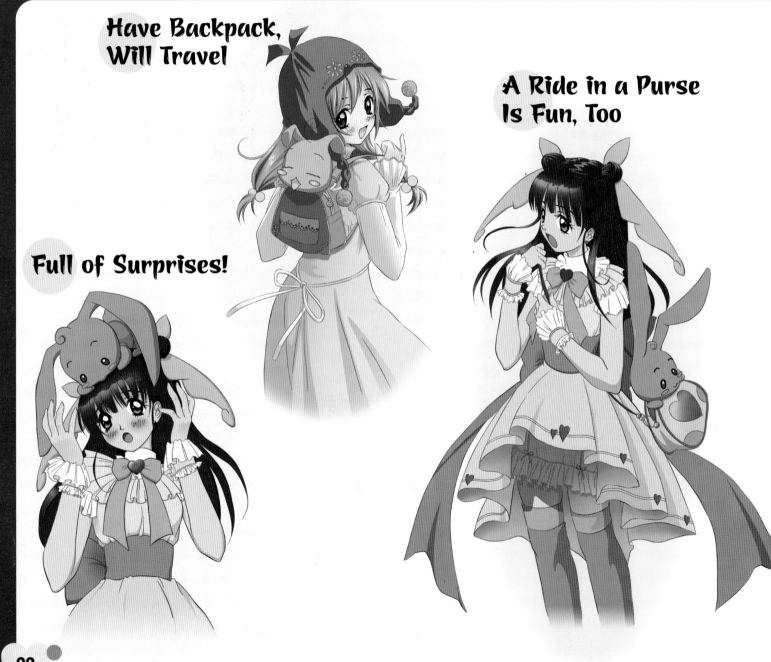

Have Backpack, Will Travel

A Ride in a Purse Is Fun, Too

Full of Surprises!

Rabbit-Type Magical Pets

Of course, the magical pet rabbit doesn't look much like a real rabbit. It's a pudgy, cartoon version that has been "tweaked" to give it a manga flair. It has big eyes, a small mouth and a tiny nose (if it has a nose at all).

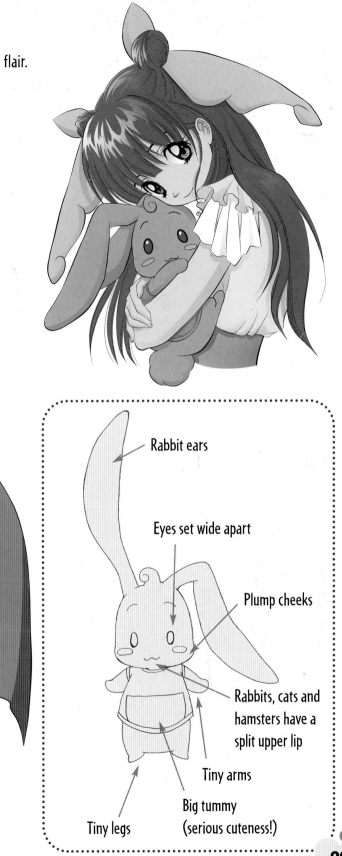

Rabbit ears

Eyes set wide apart

Plump cheeks

Rabbits, cats and hamsters have a split upper lip

Tiny arms

Big tummy (serious cuteness!)

Tiny legs

Hamster-Type Magical Pets

Any small, woodland creature—chipmunks, gophers, mice, hedgehogs—can be turned into a cute fantasy pet.

Round, bear-like ears

Huge oval eyes

Chubby cheeks

Traditional Japanese jacket

Bushy, round tail

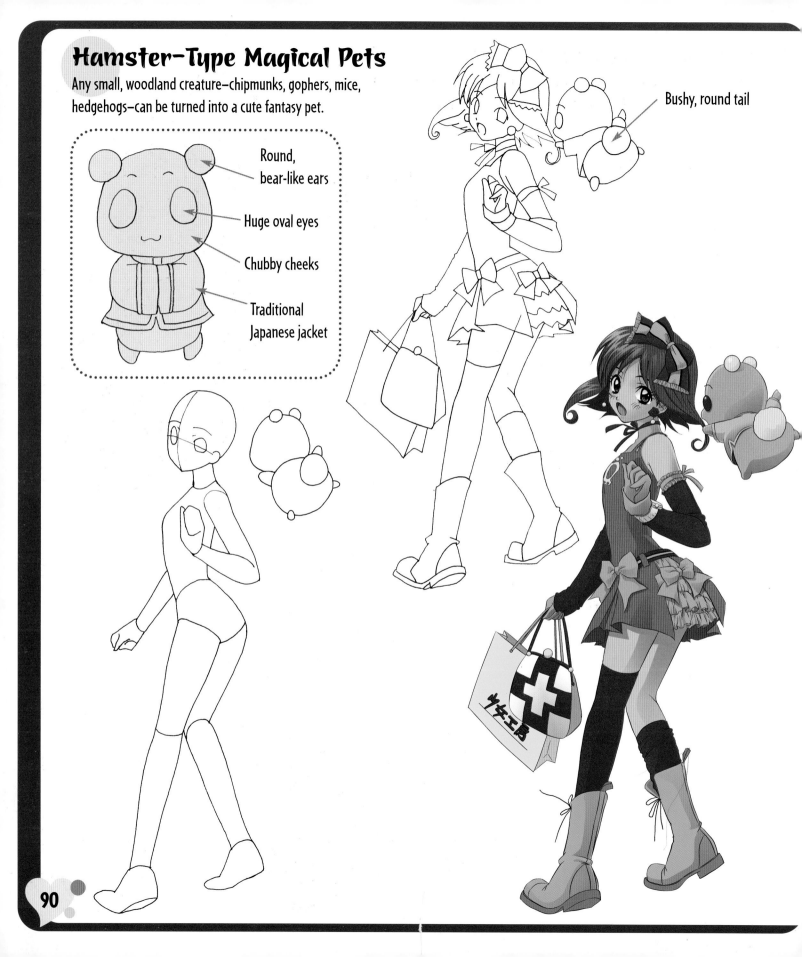

Caring for a Sick Fantasy Pet

Readers grow to be as fond of these little characters as their own dogs and cats. If you can capture the reader's sympathy, you've accomplished a lot as an illustrator.

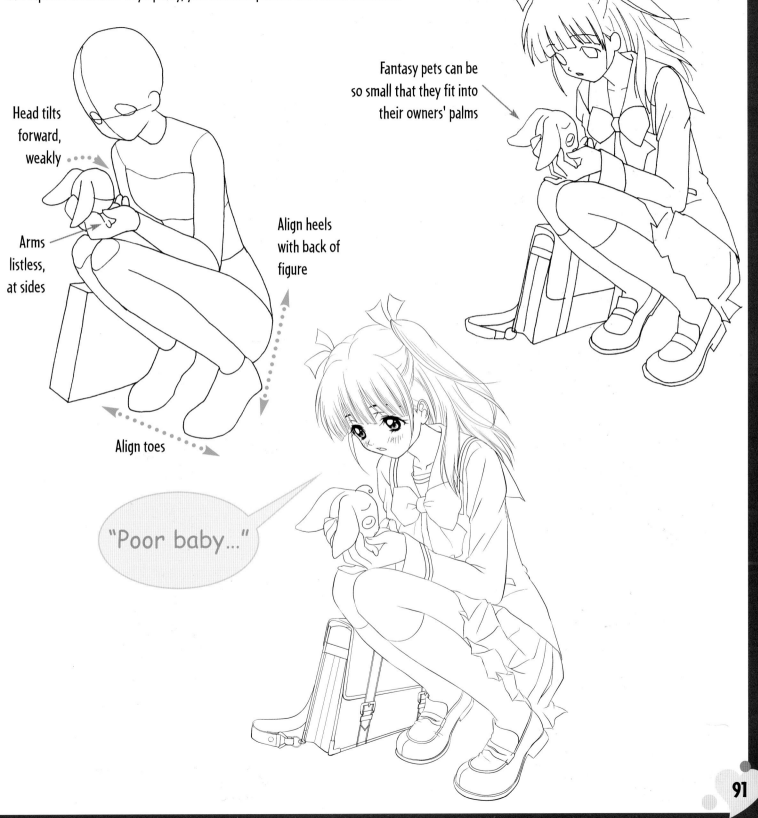

Head tilts forward, weakly

Arms listless, at sides

Align heels with back of figure

Align toes

Fantasy pets can be so small that they fit into their owners' palms

"Poor baby..."

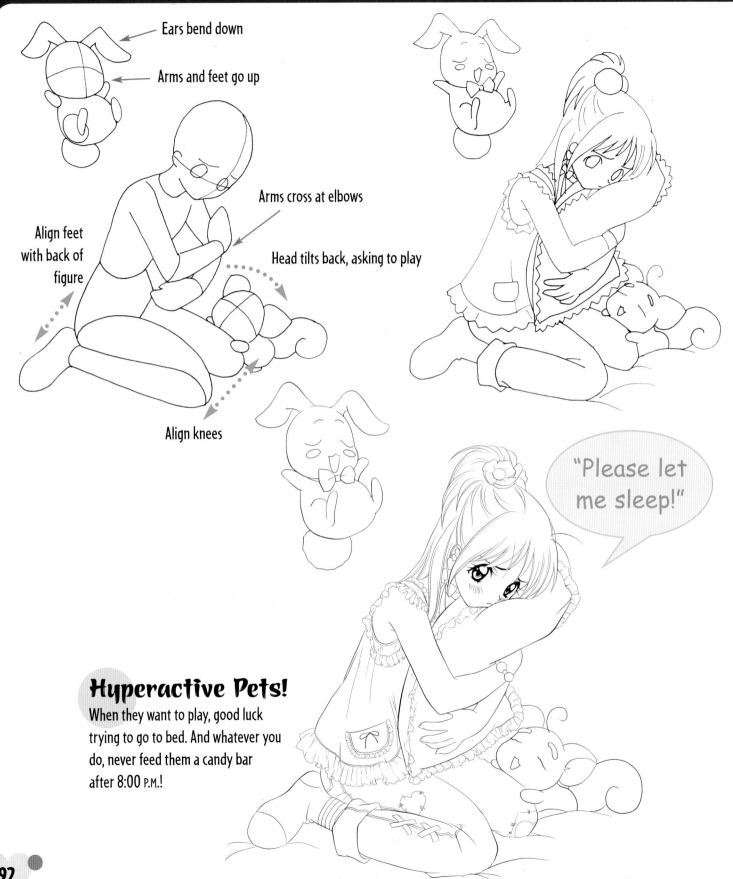

Ears bend down

Arms and feet go up

Arms cross at elbows

Head tilts back, asking to play

Align feet with back of figure

Align knees

"Please let me sleep!"

Hyperactive Pets!

When they want to play, good luck trying to go to bed. And whatever you do, never feed them a candy bar after 8:00 P.M.!

Brave Little Pet

f you're ever in trouble and your friends all run for cover, there's one pal who will never abandon you!

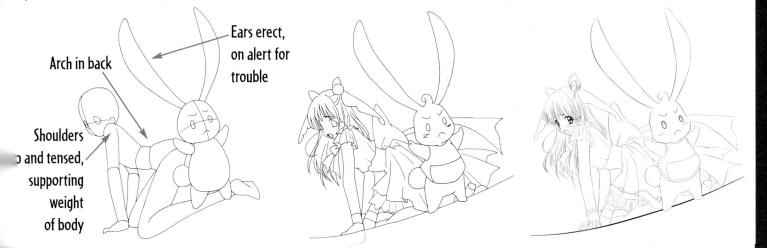

Ears erect, on alert for trouble

Arch in back

Shoulders [up] and tensed, supporting weight of body

Notice how the scene is drawn on a diagonal line. This creates a feeling of danger and instability.

More Cool Bishies

Earlier in this book we took an in-depth look at bishies, focusing on characters that typically appear in the romance genre. But there are many more types of bishies that you can call on to appear in your graphic novel. Some of these characters cross over from other genres, like fantasy. In this chapter, we draw some of these guys and also cover in detail the very popular Mysterious Boy, putting him in some common romance scenarios.

Bishie Fantasy Fighter

Bishies are extremely popular characters, and although they are most commonly seen in the romance genre, they also cross over into other popular categories of manga. For example, these dashing characters are often featured in the world of fantasy manga alongside warriors, faeries and knights. They are also well represented in the occult genre where they appear as seductive vampires.

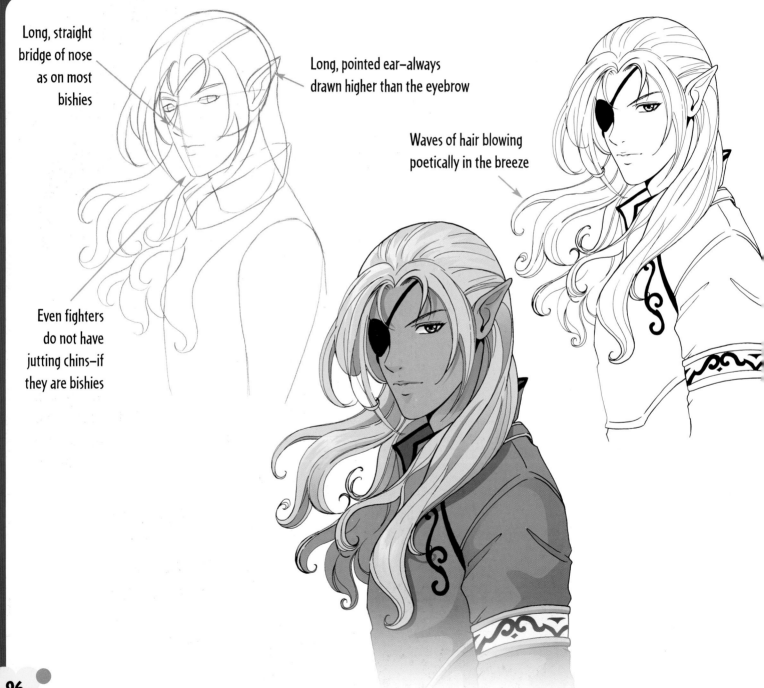

Long, straight bridge of nose as on most bishies

Long, pointed ear—always drawn higher than the eyebrow

Waves of hair blowing poetically in the breeze

Even fighters do not have jutting chins—if they are bishies

Samurai Bishie

Usually you'll see a character like this as a samurai in a dramatic story or a period piece. He's a popular and noble bishie who also crosses genres. There are futuristic and even teen adventure genre samurai bishies.

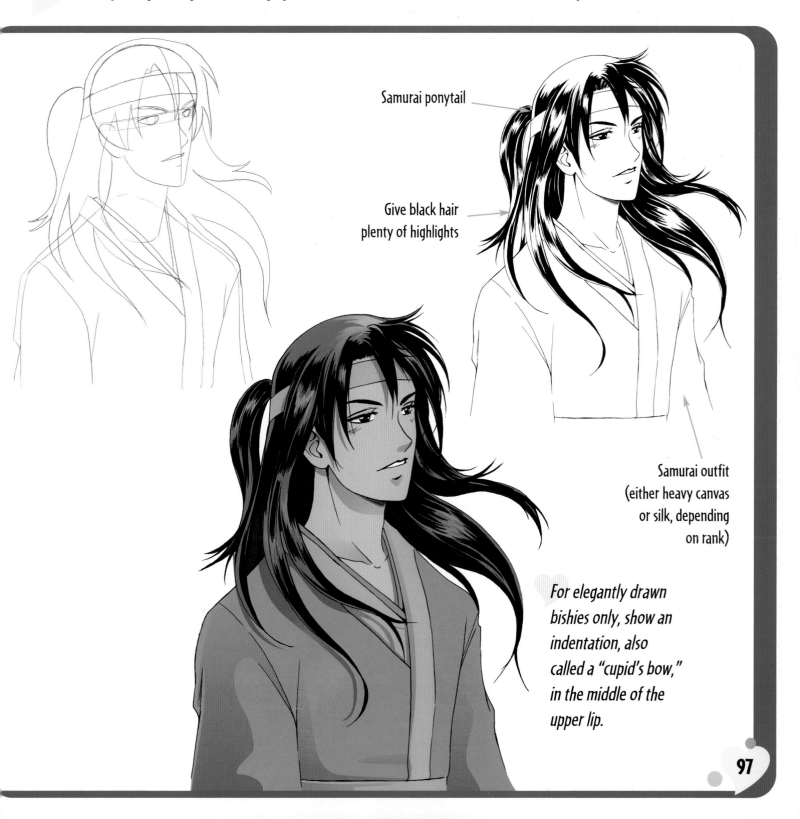

Samurai ponytail

Give black hair plenty of highlights

Samurai outfit (either heavy canvas or silk, depending on rank)

For elegantly drawn bishies only, show an indentation, also called a "cupid's bow," in the middle of the upper lip.

Emos

For some, the teen years are a time of angst and personal rebellion. Emos are emotional characters, somewhere between punks and goths. They come across like the "minor notes" on a piano. But unlike punks and goths, they're not antisocial or devoid of fashion sense. Their outfits should be strategically put together, even if they are extreme. They're more like characters on the fringe. They're not part of the in-crowd, but pride themselves on being loners— who hang out with other emos!

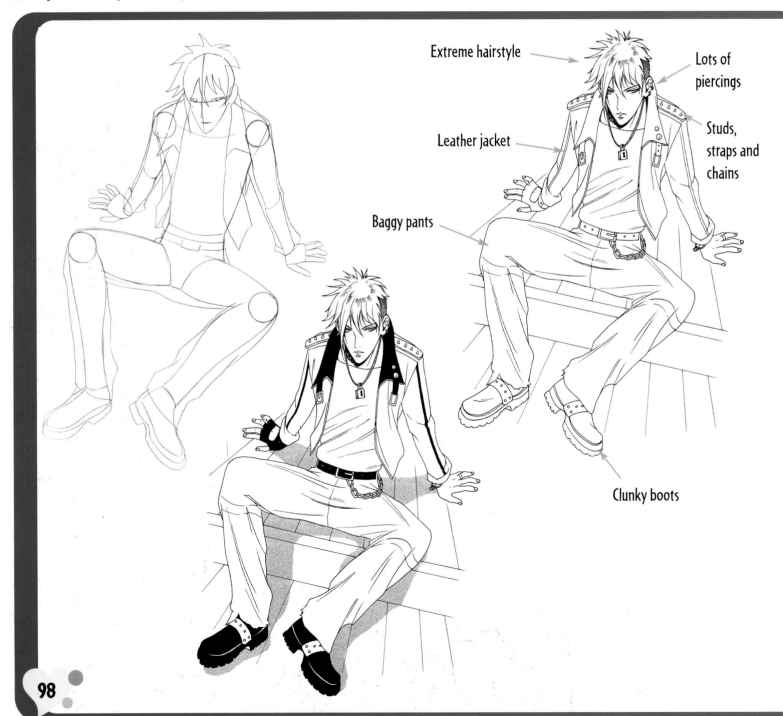

Extreme hairstyle

Lots of piercings

Leather jacket

Studs, straps and chains

Baggy pants

Clunky boots

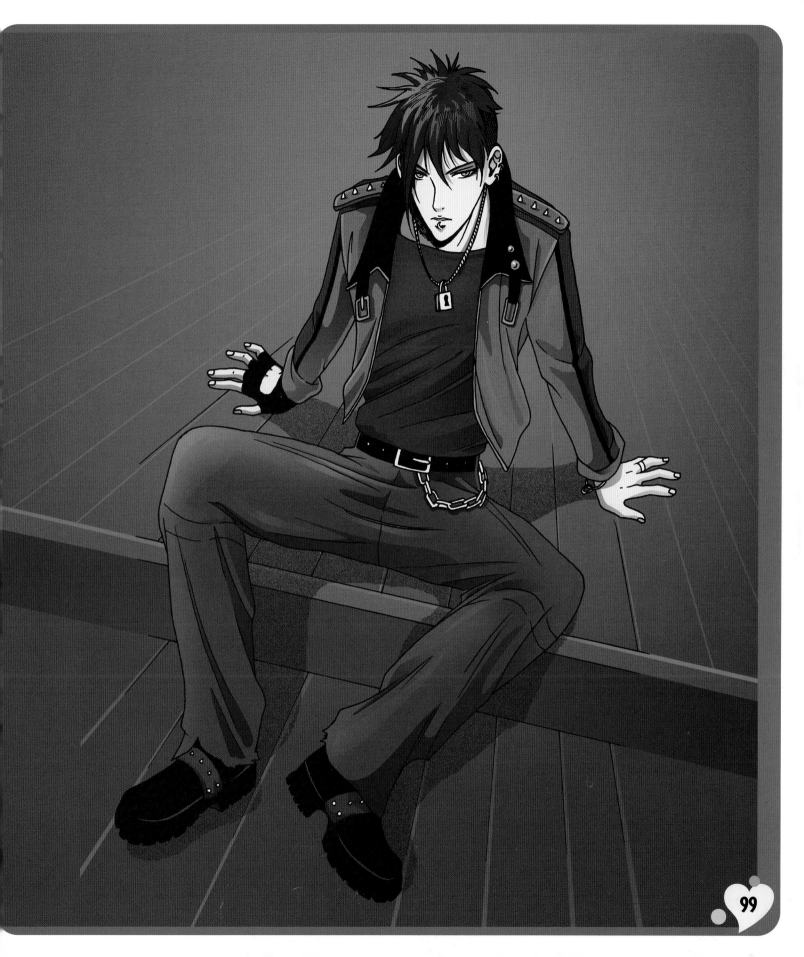

Spirit of Light

This type of character is more popular in the fantasy genre than the romance genre. However, the new trend in manga is to blend genres, so we're now seeing more fantasy-romance stories. Maybe you can come up with an idea for a romance story that uses a guiding angel as a plot device!

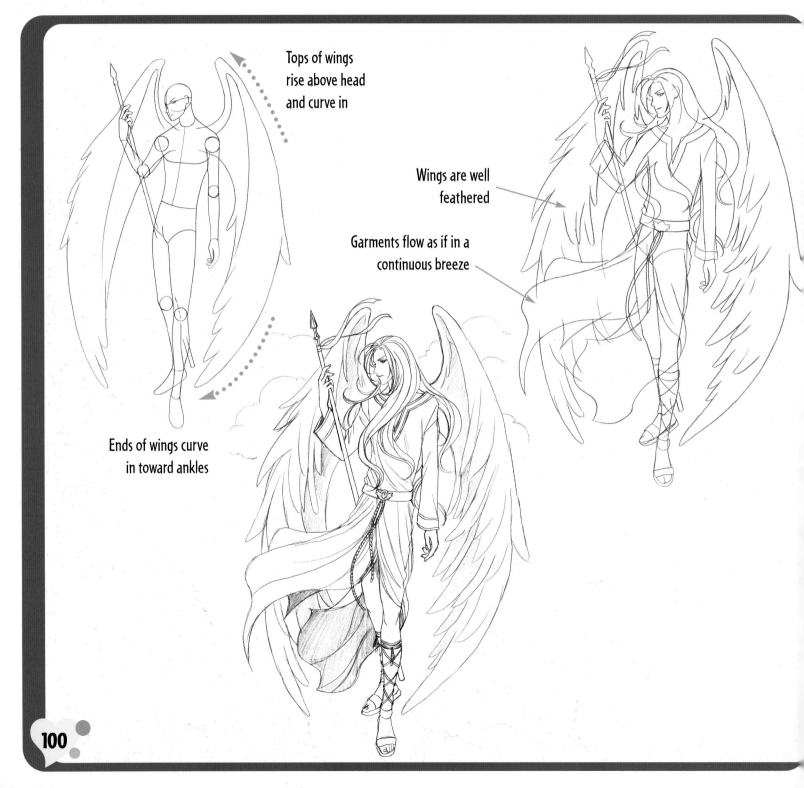

Tops of wings rise above head and curve in

Wings are well feathered

Garments flow as if in a continuous breeze

Ends of wings curve in toward ankles

He's No Angel!

It may seem counterintuitive that such a peaceful, serene-looking chap should also be such a capable fighter. But to my way of thinking, the Japanese writers who invented this type are really on to something that the comic book writers in the West have overlooked. If you have a huge lug of a guy who loves to fight and wins lots of battles, well, there's no great surprise there. However, if you have a tranquil spirit who shows up only when disturbed by injustice and won't back down from a challenge, then you're going to wonder if this spirit guy is crazy. Or is he really more formidable than he appears? Readers will certainly want to stick around and find out!

These angel-types are typically aggressive, vicious fighters when provoked and are tough to defeat!

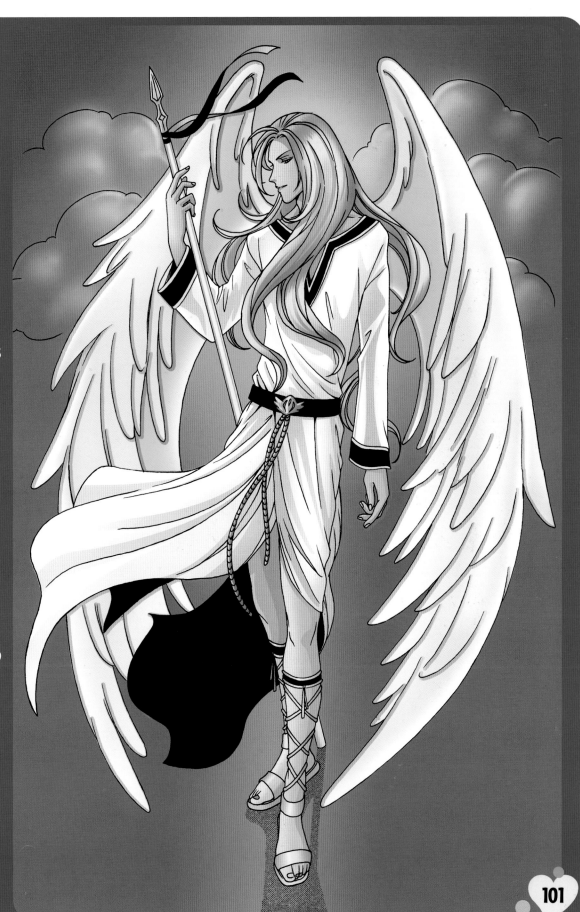

The Mysterious Boy

He's from out of town. We don't know where. He's a loner. Good-looking, but not interested in impressing the gossipy girls. What's his deal? No one knows. There's a dark charisma about him, and a vague sense of danger. He's slightly troubled, yet supremely self-confident, almost derisive about the other guys in the school everyone else looks up to. He's not looking for trouble, but if you start something with him, he can back it up with his expert martial arts skills. All of this makes him an irresistible character to readers. Whenever he's on the page, you've just got to keep reading to see what's going to happen next, because the fuse has been lit, and eventually he'll explode into action, breaking a few hearts along the way.

The Heartbreaker

Girls will try, but they can never possess him.

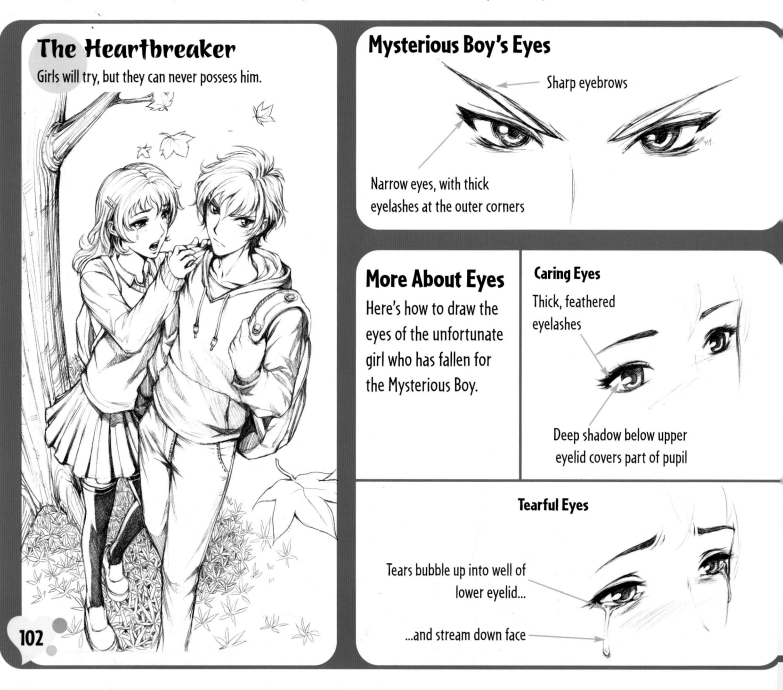

Mysterious Boy's Eyes

Sharp eyebrows

Narrow eyes, with thick eyelashes at the outer corners

More About Eyes

Here's how to draw the eyes of the unfortunate girl who has fallen for the Mysterious Boy.

Caring Eyes

Thick, feathered eyelashes

Deep shadow below upper eyelid covers part of pupil

Tearful Eyes

Tears bubble up into well of lower eyelid...

...and stream down face

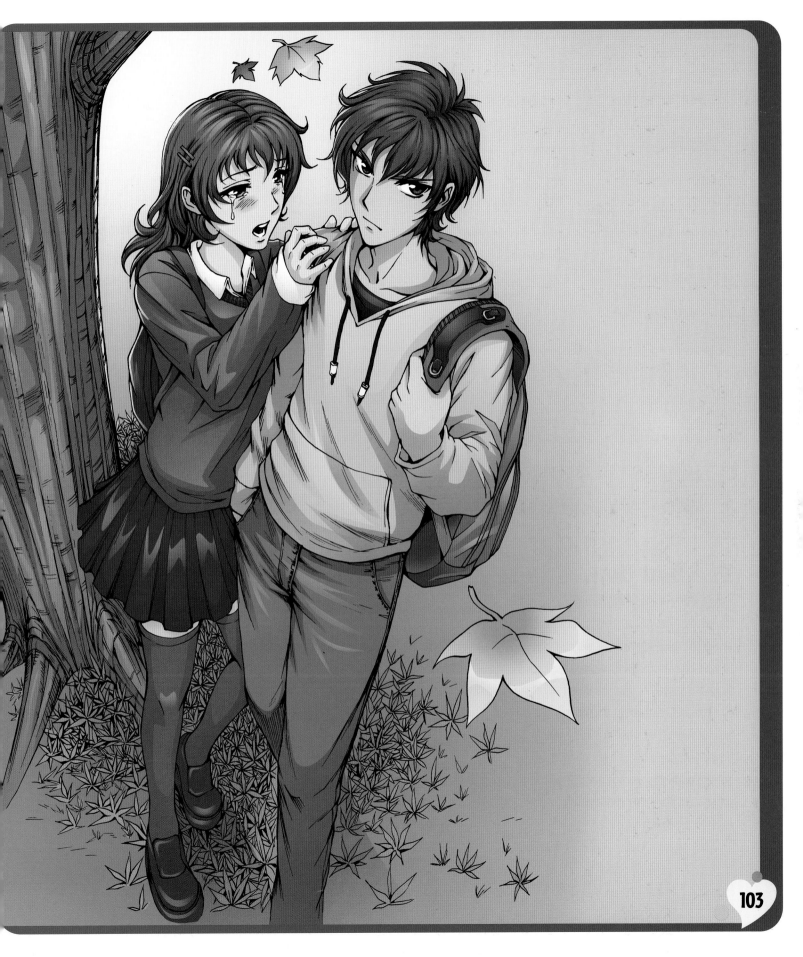

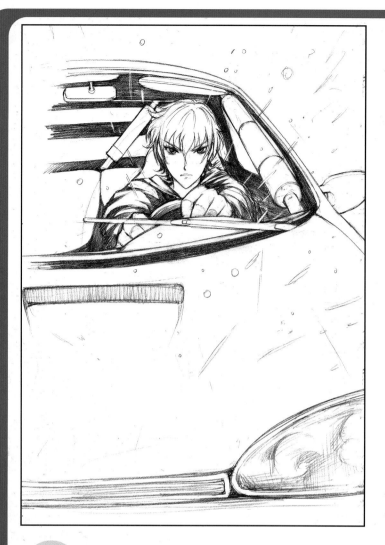

The Bad Boy

The Bad Boy is a version of the Mysterious Boy, just ratcheted up a notch. This is the guy your mother warned you to stay away from. Well, maybe you should listen to her. But she didn't say you couldn't read about bad boys in graphic novels, did she? I could never figure out where these bad boys got the money to pay for all their terrific sports cars. My paper route barely covered my Nikes.

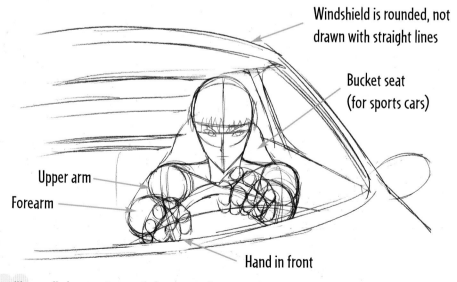

Windshield is rounded, not drawn with straight lines

Bucket seat (for sports cars)

Upper arm

Forearm

Hand in front

"Layer" the sections of the arm when drawing it in perspective (foreshortened).

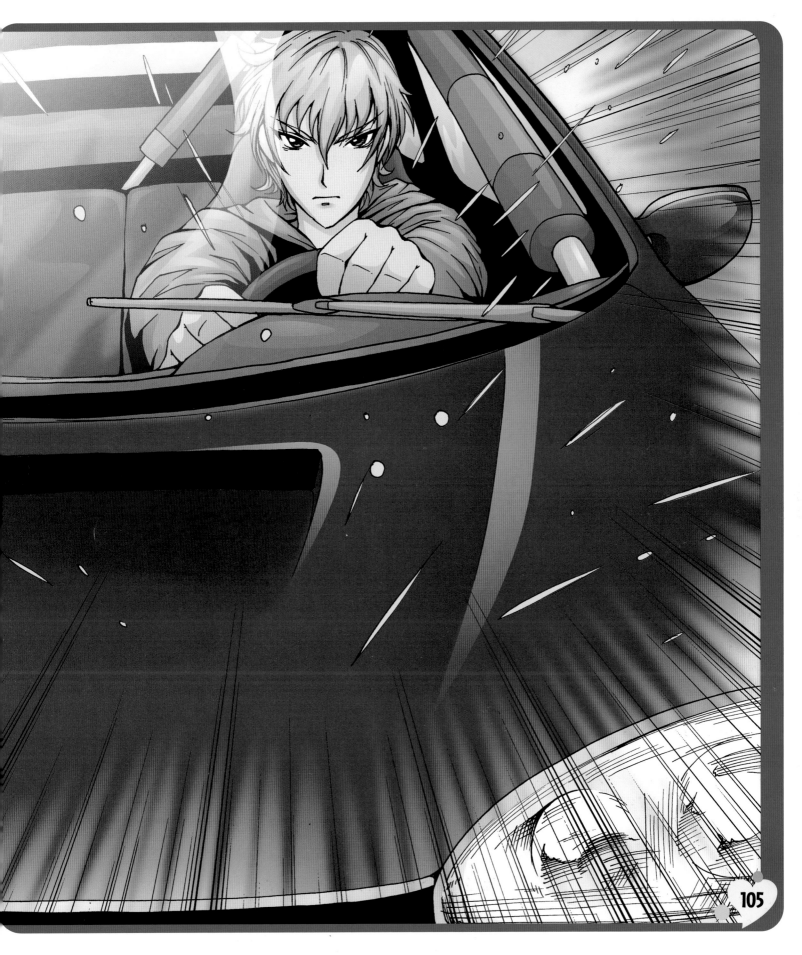

They All Have a Crush on Him!

The mysterious boy may be the new guy on campus, but he is usually the focus of attention. Among the girls, that is. The boys can't stand him!

Dynamic Compositions

Professional manga artists, like all cartoonists, try to create depth in their scenes by layering the foreground, middle ground, and background. They also "weigh" both the left- and right-hand sides of the page. Sometimes it looks better if both sides have the same weight—the same amount of "stuff" (symmetry); at other times, it looks better if one side weighs more than the other (asymmetry). Third, drawing a scene along diagonals creates a more dynamic look. Here, in the rough sketch for this scene, you can see the diagonal sketch guidelines (also called vanishing lines) that have been used as the basis of the scene. That is why the group of girls appears higher on the page than the bishie boy.

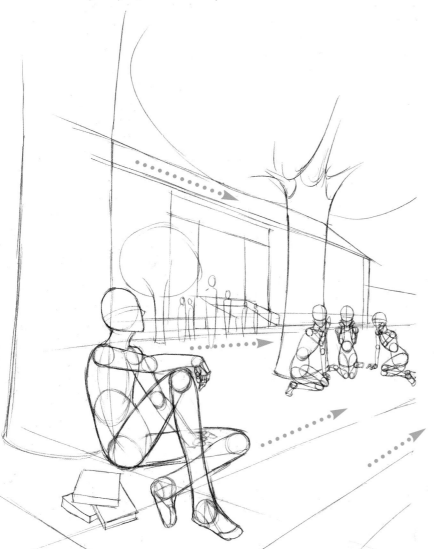

When drawing multiple characters, each expression must differ from the others. Remember the rule: "Repeating is cheating!"

Note the extensive shading on the underside of the treetops. Light from the sun never hits that surface, so it always appears in shadow.

New Kid in Town

Wherever the New Kid goes, he makes waves. He doesn't move over for anyone—you make room for him. If you're the captain of the baseball team, it doesn't mean anything to him. The boys resent him.

The girls are strangely intrigued. Here he is walking down the school hallway, bumping right past the surprised school jock, who is used to intimidating everyone else.

Up & Down Composition

Sometimes the sketch lines in a drawing will converge in two different points, called vanishing points. Vanishing point A is a point chosen at any randomly selected height over the character, but directly in the center of the page. All of the characters' bodies are drawn so that they converge along these lines toward this vanishing point. The lines of the walls and the ceiling of the school hallway converge, like sets of railroad tracks, into the distance, and finally disappear at vanishing point B.

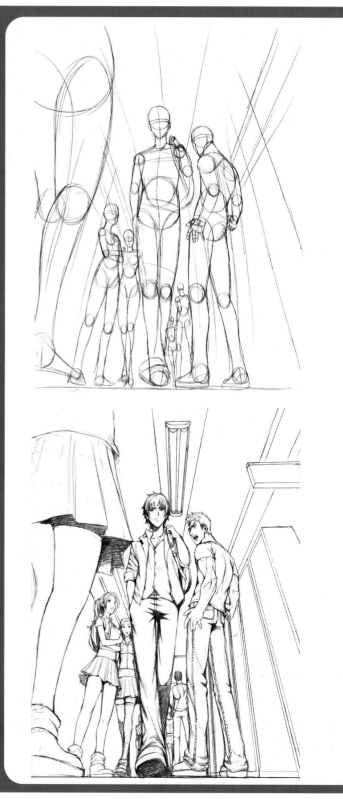

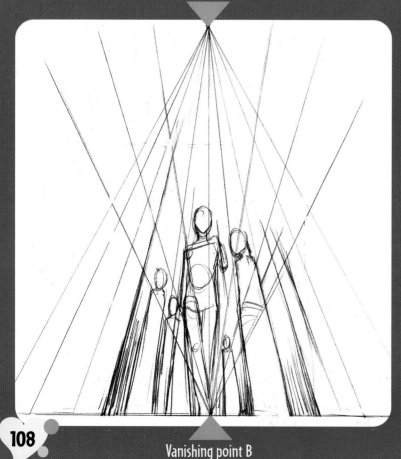

Vanishing point A

Vanishing point B

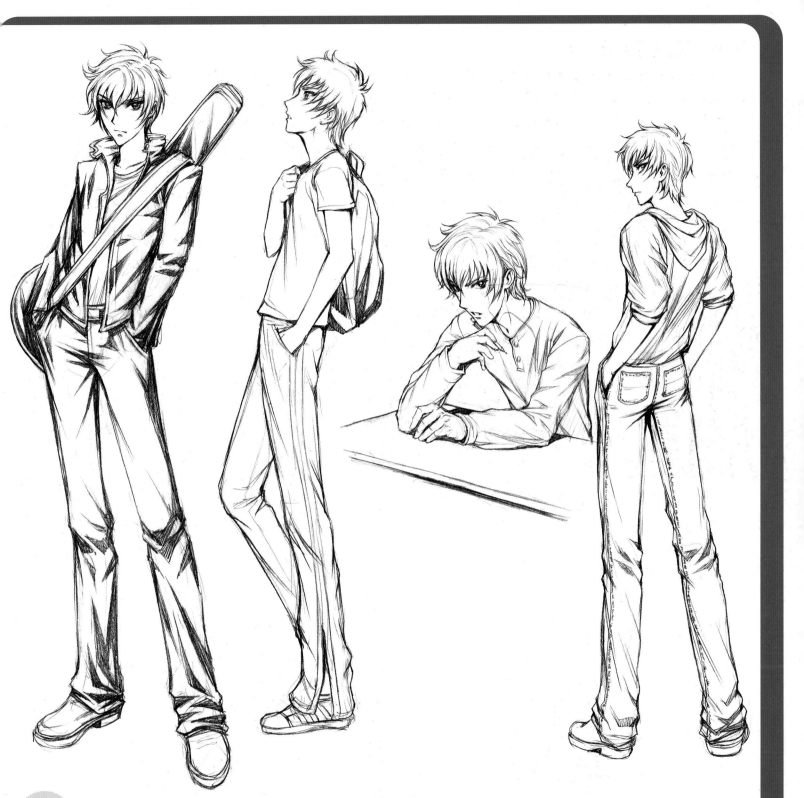

Mysterious Boy Outfits

The mysterious boy is always from "the wrong side of the tracks." Therefore, he doesn't wear the school uniform, but instead wears casual clothes, perhaps a bit too casual. He can appear to have a lack of respect for school, but he is never a goth, or sloppy. He's got to always look good enough to maintain that "cool" factor. Here are some examples.

The ABCs of Scene Staging

This chapter offers one of those rare instances in which you don't have to draw in order to learn to draw! This is a conceptual chapter. Of course, I encourage you to practice drawing any of the illustrations in this chapter that you like, but it's not mandatory. This chapter is designed specifically to give you new ideas. It will change your approach to staging scenes, AND it will help you understand the "how" and "why" of effective scene staging.

Drawing Two People in a Scene

An important element of drawing comics is learning how to draw people interacting. You can read through most other how-to-draw books and never find any information about drawing more than one character at a time. But can you imagine reading a graphic novel with only one character in it? I can't either, so I thought you'd like this section. It's really all common sense, but translated into a visual format.

Friends Chatting

This is the most typical two-person setup in romance graphic novels: two friends chatting. It looks casual and easy to draw–and it is–but there are several principles to follow in order to make it look that way.

Do's & Don'ts of Drawing Multiple Characters

Here are some tips for drawing scenes with two or more characters in them.

Do

- Draw them at different angles, like closeups, medium shots and full shots.
- Vary the characters' expressions.
- Vary the characters' heights.
- Vary the characters' arm gestures.
- Draw them at ages that would normally relate to each other.

Don't

- Draw them too close together or too far apart.
- Give them clothing that indicates different temperatures (in other words, one character shouldn't wear a sweater while the other wears a sleeveless outfit).
- Have both characters talking at the same time if one of them would be better off listening.
- Always pose them in the side view—it's flat. Instead, vary it.
- Always pose them looking directly at each other. They can look at other things and still be a couple, even while talking to each other.

When Boy Meets Girl

Keeping a little distance between characters shows shyness, which can be appropriate for first-time encounters. Note how the boy's gesture leads to the girl's, like dominoes. First, he tips his hat, then she raises her hand playfully to her face, smiles and points her toe. This is a couple who will most likely hit it off. That is, until his girlfriend strolls by!

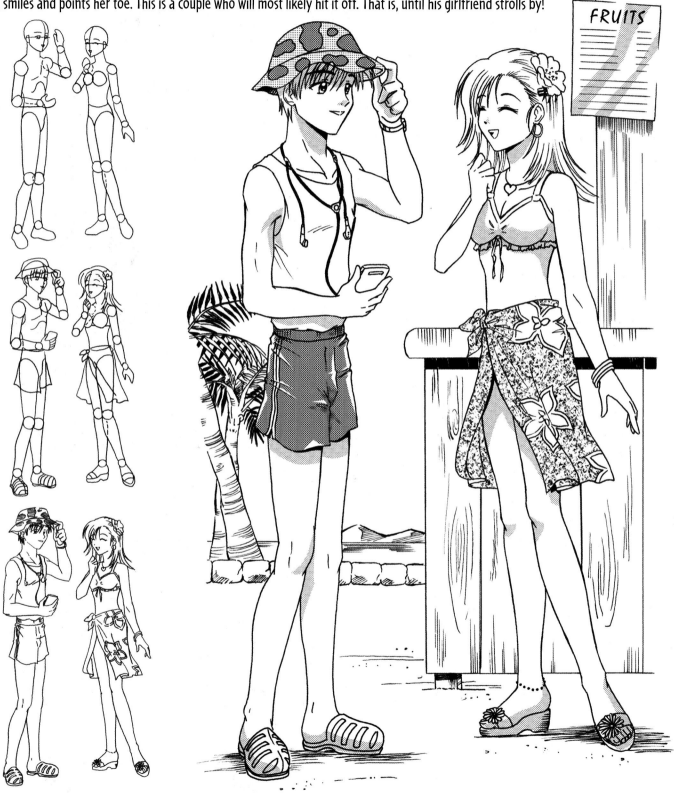

FRUITS

Cosplay!

When two manga fans meet at a Comicon, and both are wearing costumes from the same anime show, the sparks can really fly! Here's an example of how, by posing the scene with a little inventiveness, it becomes livelier. The beginner would pose these two sitting on the bench talking to each other. It's functional, but not a whole lot more. The intermediate would pose one character on the bench and the other standing. It varies the look, but it's still not energetic.

But a pro will draw the pose so that one character sits on the bench while the other character is walking past, when suddenly, mid-stride, the walking character notices the seated character's costume. Sure, it's a small difference, but notice how much energy this third way has.

So how can you make changes like these when you have scenes of your own to draw? Just ask yourself, before you draw, "How can I add a little more attitude to the pose?"

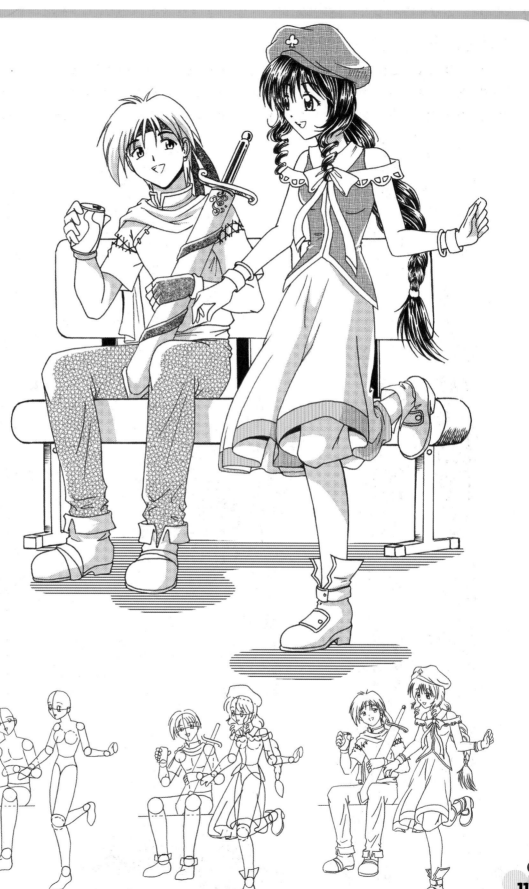

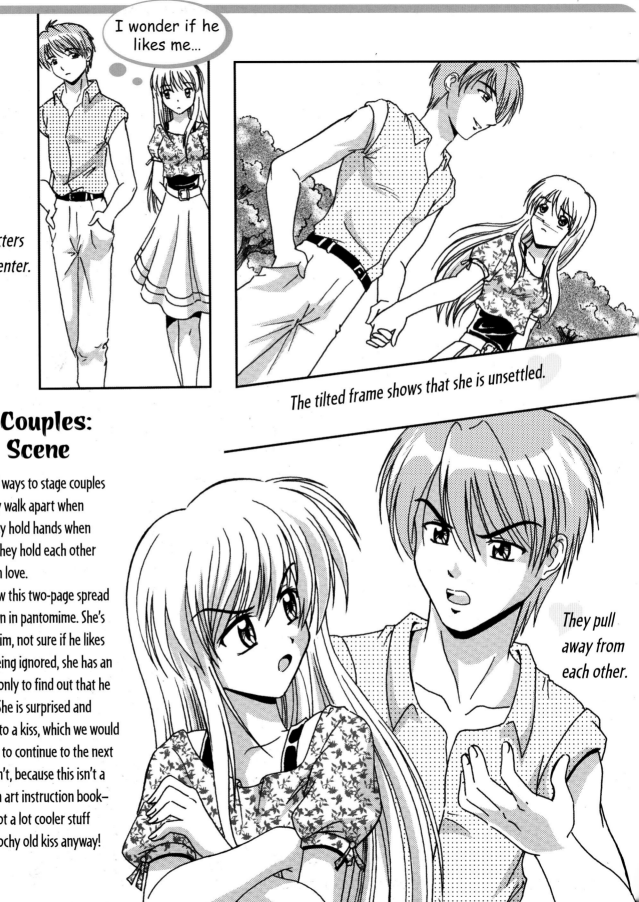

I wonder if he likes me...

Both characters avoid the center.

The tilted frame shows that she is unsettled.

Drawing Couples: Scene by Scene

Here are a variety of ways to stage couples who are dating. They walk apart when they're insecure. They hold hands when they're secure. And they hold each other close when they're in love.

We can also view this two-page spread as a story progression in pantomime. She's walking along with him, not sure if he likes her. Then, tired of being ignored, she has an argument with him, only to find out that he really does like her. She is surprised and happy. This will lead to a kiss, which we would see if the story were to continue to the next page. But alas, it won't, because this isn't a graphic novel, but an art instruction book—and frankly, we've got a lot cooler stuff to cover than a smoochy old kiss anyway!

They pull away from each other.

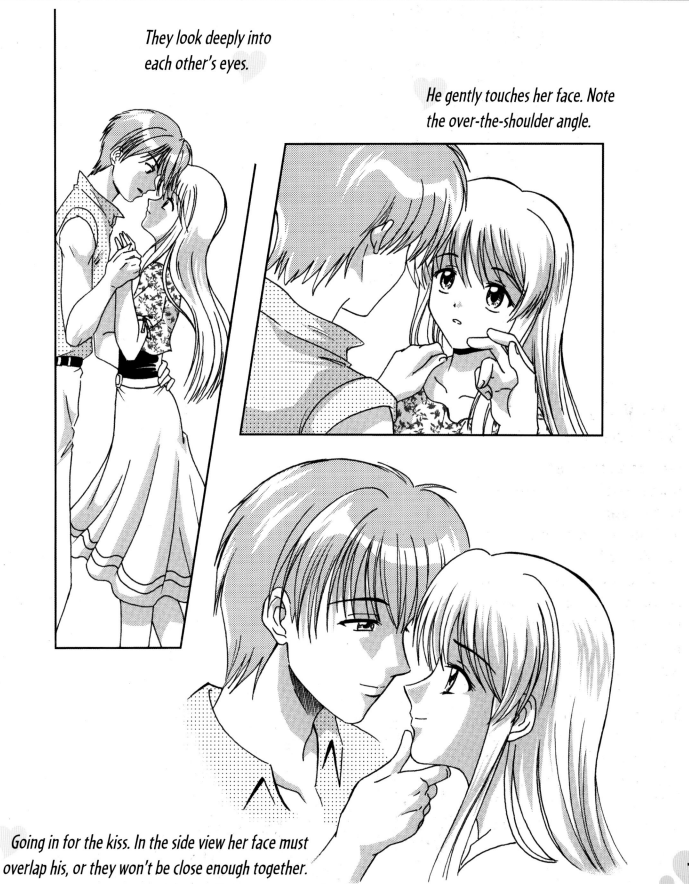

They look deeply into each other's eyes.

He gently touches her face. Note the over-the-shoulder angle.

Going in for the kiss. In the side view her face must overlap his, or they won't be close enough together.

Action Scenes

Action should be exciting, not static. That's just common sense. I want to make sure that you don't work very hard on drawing a great action scene that is destined to be rather tepid. Flat and side angles are usually not good first choices for action scenes. They have the unfortunate effect of making the figures appear frozen in suspended animation, like two statues, even if the figures themselves are well drawn. The eye wants to see action drawn with these things going for it:

- A steep diagonal
- A foreground/background dynamic to create depth
- Characters of varied sizes due to perspective
- Special-effect streak lines

Flat Angle

This side view shows no urgency. It's too flat and is two-dimensional. The reader can't get into the picture and doesn't become emotionally involved.

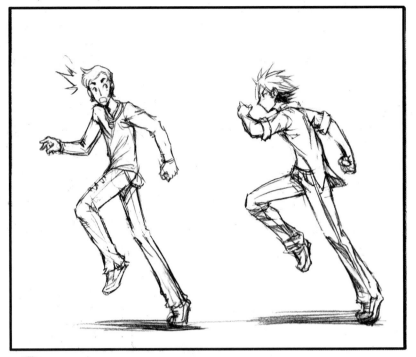

Deep Angle

Drawn at an angle, the characters appear to run deeper into the picture itself, and the reader's eye follows, becoming more involved in the unfolding drama.

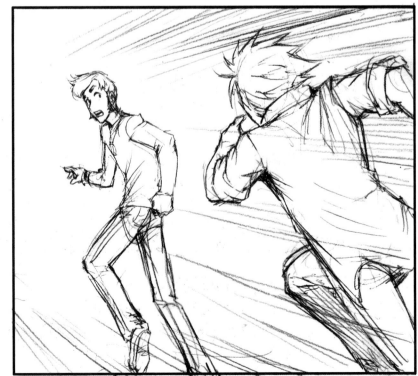

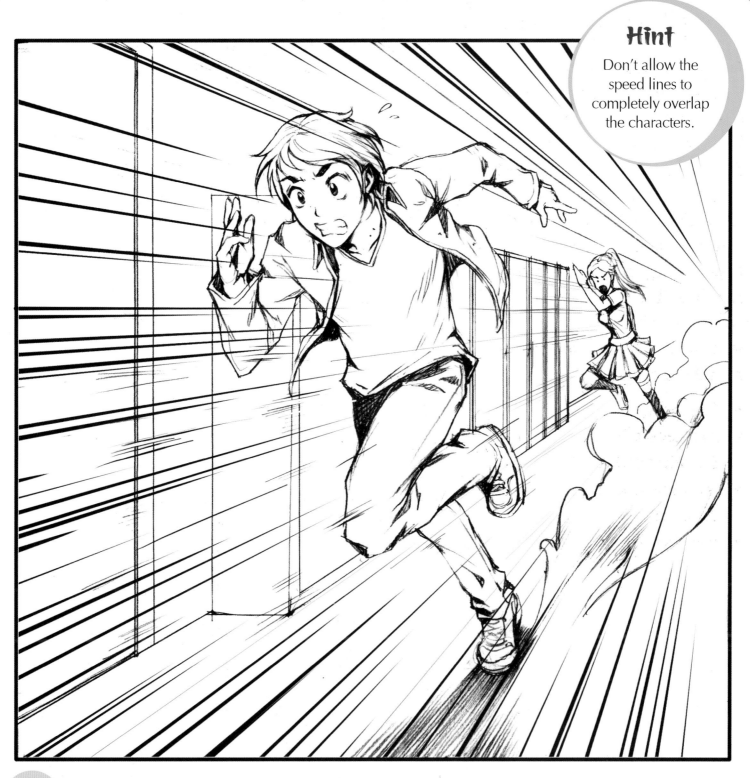

Hint

Don't allow the speed lines to completely overlap the characters.

Super-Exaggerated Depth

With the aid of diminishing speed lines that travel into the distance, this type of scene creates super-depth. It is excellent for showing characters moving across large distances. Be sure to greatly enlarge the size of the characters as they come closer to the reader, due to perspective.

Group Shots Vs. "Two-Shots"

Here, we start off the scene by establishing a group of students in a classroom situation. We haven't narrowed down the focus yet.

We want to then follow it up by cutting to a closer shot of the two main characters—our stars. So we change the angle to a flat, front view. This has the effect of cutting out the rest of the world and giving the two characters a more intimate feeling, as if the panel creates their own little room. Can you see that? And since there's no action, a flat front view works well.

Group Shot on a Diagonal

This is a good angle with which establish a larger group of characters. Staging them all in a front view would look like a police lineup!

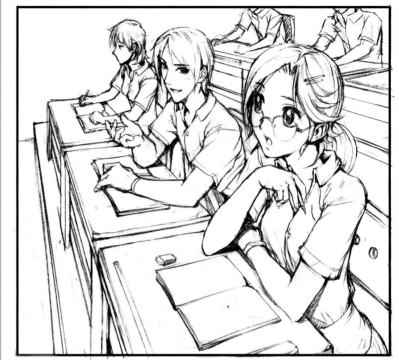

Two-Shot: Flat Front View

The flat front view may not be good for action scenes, but it is useful for focusing the reader's attention on a limited number of characters.

Filling the Panel

You can't—and shouldn't try to—squeeze complete figures of both characters into each panel at all times. It isn't necessary, and in this example, it would make the panel so wide that it would end up losing focus and looking empty. But which character do you allow the panel wall to chop in half? (Please pardon the gruesome metaphor!)

As a rule, it's preferable to show all of the far character and cut off the character in the foreground.

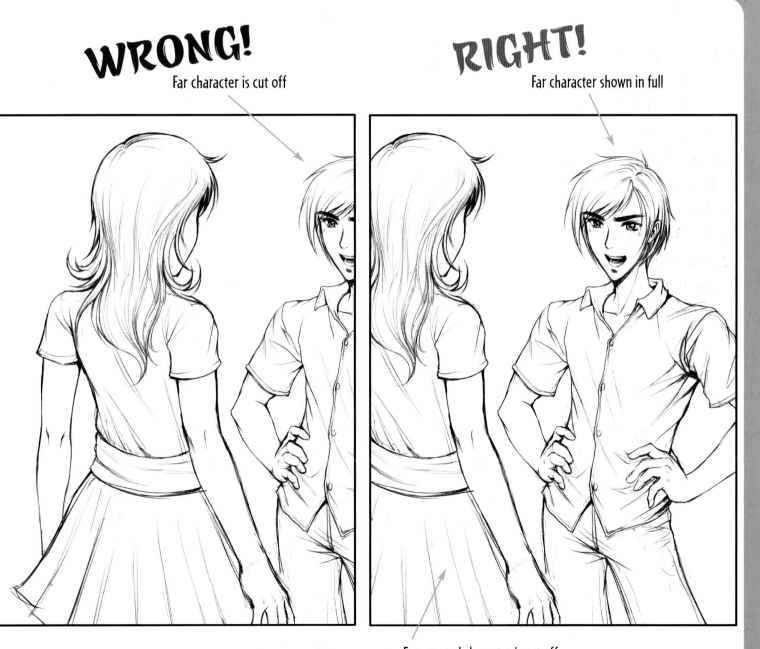

WRONG!

Far character is cut off

RIGHT!

Far character shown in full

Foreground character is cut off

Extreme Drama Takes Extreme Angles

The Mysterious Boy walks down the hall, but the school athletes block his way. What's he gonna do? This could spell trouble. No one messes with these jocks!

The side view is a good, clear choice. But it's nothing new. In order to heighten the drama, there is not much we can do to the actual drawing itself, which is already very good. For the answer, we'll have to look elsewhere, to the "camera" angle. For extreme drama, we either go below or above the character. But going below (looking up at a character) makes a character appear huge, awesome and creepy in the eye of the reader. None of those descriptions seem to fit the Mysterious Boy or this scene. On the other hand, changing the angle to look down at the characters gives a sense of the surroundings and a feeling that we are observing the situation—perfect!

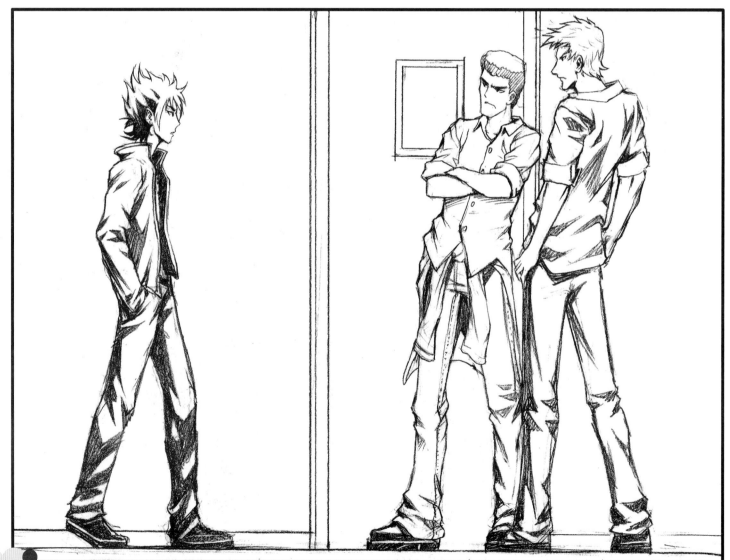

Now we really feel the impending conflict! The tension is awesome. I believe you're now starting to understand the value of choosing the correct angle for the correct moment. You can't get this type of drama from a drawing alone without the correct angle to match it. This is called a "down" shot or a "bird's-eye view."

Good Cuts & Bad Cuts

When you cut from one panel to another, you don't want to jar the reader, unless that's the point, as in some fast and furious action scenes. For the most part, the "cuts" should flow smoothly from one to the other. There are two ways to do this: Move in toward the character, or move around the character. (Moving up or down is reserved for more dramatic shots.) If your move from one angle to the next is too big, with no baby steps in between, it can also be jarring. So let's take a look at some what-to-do's and what-not-to-do's.

Full Shot to Medium Closeup: Front View

This is a very safe, standard cut. Not too close, not too far. We have simply moved closer in to a comfortable distance.

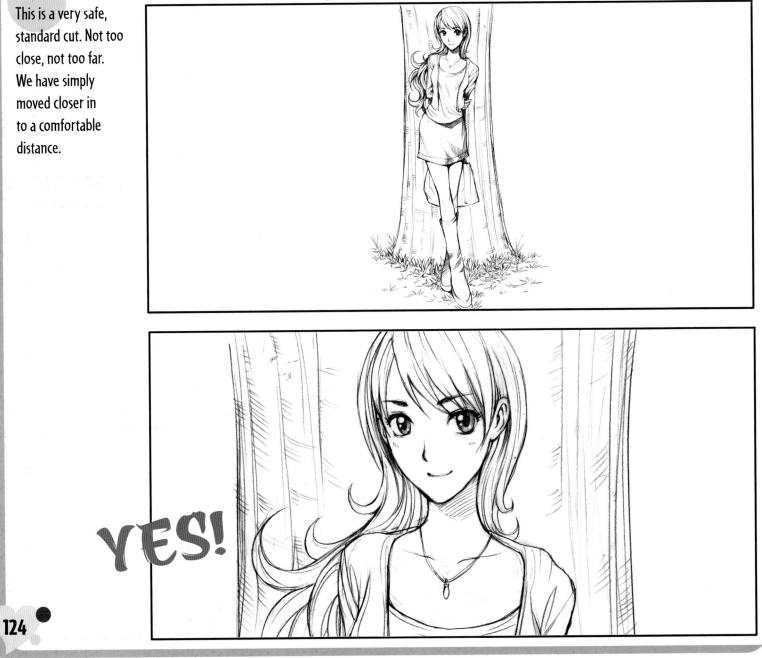

YES!

Full Shot to Medium Closeup: 3/4 Angle

Now we not only move in, but we also move around the character into a 3/4 angle. This angle involves the reader a little more because it brings us into an entirely new angle, and therefore, we're expecting something new to happen. Perhaps someone is arriving to talk to her.

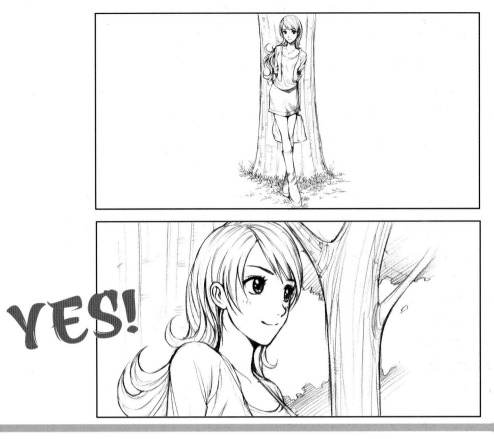

YES!

Full Shot to Rear Closeup

This time, we've moved too far around the character without enough steps in between the full shot and the closeup to prevent the cut from appearing abrupt. This shot sequence, as shown, doesn't work at all.

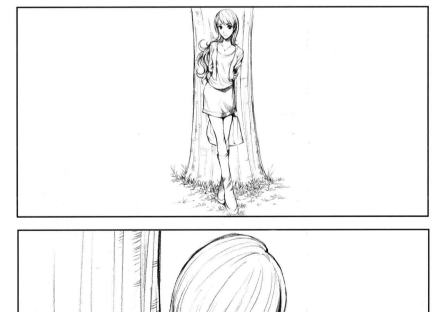

NO!

Extreme Closeups

The extreme closeup is a fantastic tool to use in highly dramatic situations. It's the exception to the rule that you need gradual steps when cutting from one angle to the next. The extreme closeup should be an abrupt cut. Just go for it, without the in-between steps. It's essential to crop most of the face off at the borders of the panels for this shot, but leave all of the eyes in–AND–just as importantly, leave empty space in front of the face.

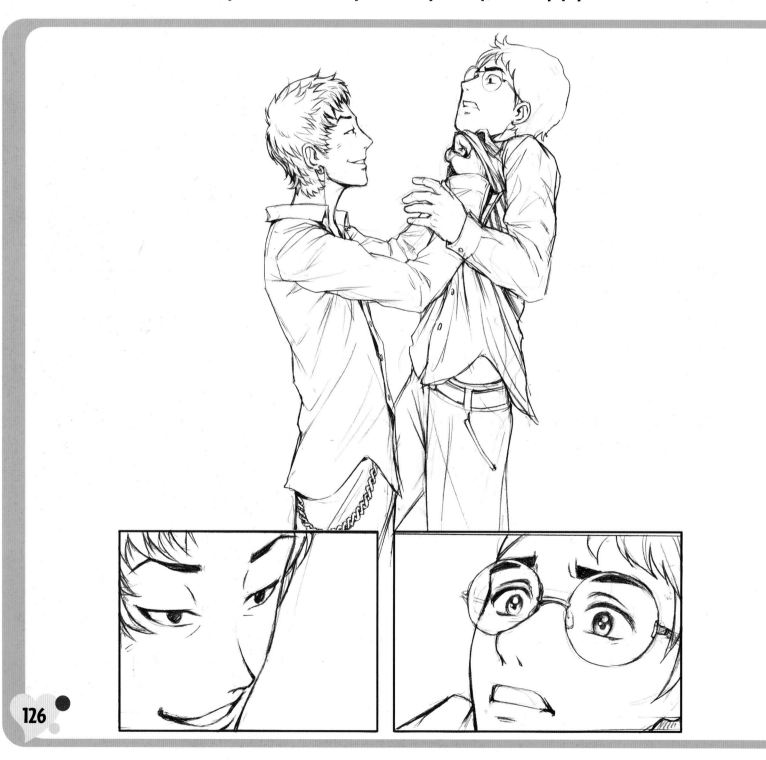

Tilted & Odd-Shaped Panels

We can also tilt the angle and alter the shape of the panel itself. But don't overuse this technique. You don't want a page full of weird-shaped panels. One is enough for an accent. If they're all weird-looking, none will stand out. Use the strange-shaped panel in conjunction with major moments in your story.

You can also use odd-shaped panels for times when you just want to break the monotony of a spread (a "spread" is two pages that face each other when a book is opened). No matter how pretty the pictures are, if the left page has six square panels and the right page has six square panels, then the first impression the reader will get is: B-O-R-I-N-G-! But by tossing in a couple of odd-shaped panels, you spice things up and hold the reader's interest.

Normal Panel

Tilted, Odd-Shaped Panel

The Reveal

The "reveal" is a popular, often humorous device in the romance genre, which is filled with comedic moments. It occurs when something funny and unexpected has just happened, and it's shown to the audience. What's more, the characters must show a big reaction to it—because that's what cues the audience in to the fact that something out of the ordinary has just taken place. Not all reveals are funny. Some can be surprising. But the principles are the same. Here are some examples of subjects ripe for revealing.

Embarrassing Moment Reveal

She just accidentally found her brother's underwear in her dresser drawer. And those polka dots are raising all sorts of questions.

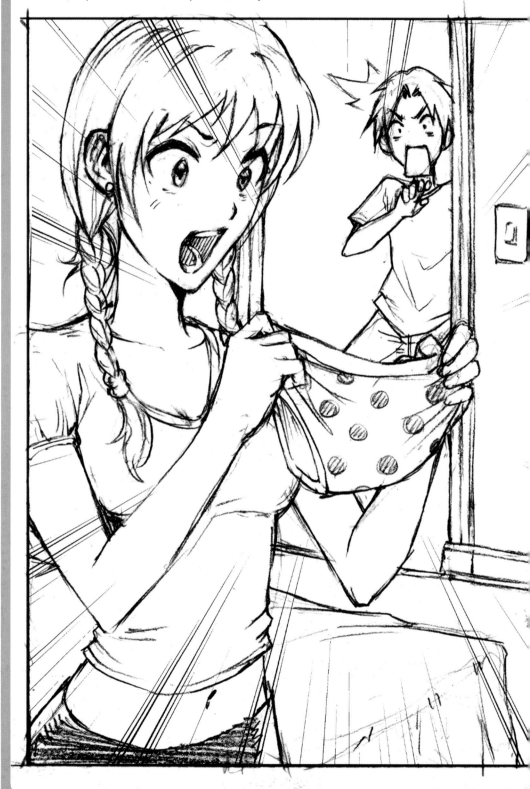

Treasure Chest Reveal

Revealed objects often radiate special-effects lines that give the drawing a magical, powerful quality.

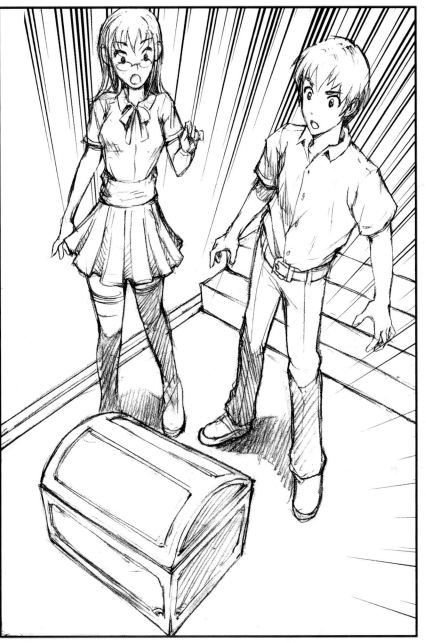

The Double Reveal

Split into two panels, the double reveal features a setup and a payoff.

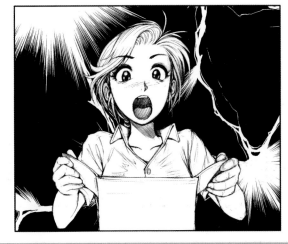

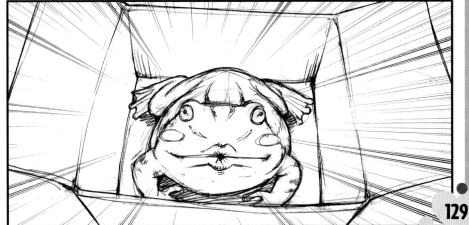

Finishing Touches

Once you've designed your characters, clothed them and placed them in exciting scenes, you have to give them something to say! This chapter covers all the aspects of using speech balloons AND shows you how to add special effects and other touches to give your drawings that extra pizazz that will put them over the top!

Special Effects

Special effects are very important in the romance genre. They enhance the mood, embellish the art and amplify the state of mind of the characters.

And there's one more reason to include special effects: They just plain look pretty! The last reason may be the most important of all.

Full-Moon Effect

Any circle behind two characters creates a romantic mood. It doesn't even have to be a literal moon. It can just be a sphere that sets the scene. Notice the edges that create the outline of the circle, and how they gradate from black to gray to white—it's not a hard line. Frame your characters' heads in the middle of the circle. If you're going to draw a literal moon, then the full moon is the best. The cresent moon is used exclusively for occult comics. And half moons are avoided altogether in comics, because they look like strange, incomplete shapes in the sky.

Stars

This is a fanciful effect that gives a carefree, cheerful feeling. It also adds a bit of glamour to a scene. The stars should be gathered in random bunches and trail off, almost like leaves in the breeze. You can often buy these effects online or purchase them from an art store. But it looks just as good to draw them freehand. If you do decide to draw them freehand, I recommend drawing them with a light gray marker without outlining them in black. This will give them a cool effect, making them look sort of translucent.

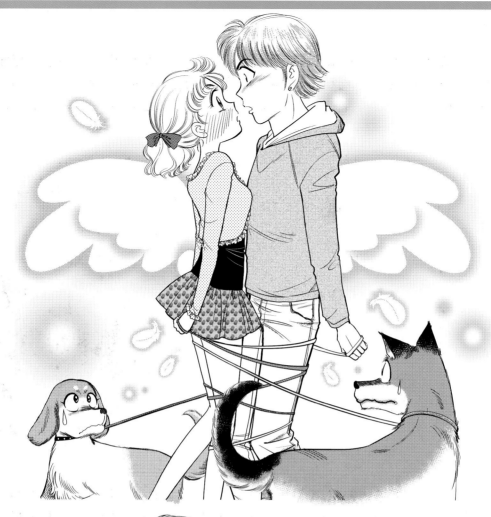

Blush Clouds

Special effects sometimes visually externalize what is going on with a character internally. Here we have a character who is extremely embarrassed because her dog has tied her up to a boy she's had a crush on but has been too shy to talk to. The moment is so big for her that it warrants more than a few streaks on her face. A cloud of emotion bursts onto the scene behind the two of them. And because the special-effect cloud is placed evenly behind the two characters, it has the effect of bringing them together as a single unit instead of as individuals, which also underscores the intention of the scene.

Repeated Dots

Repeated dots like these are a humorous, abstract design that conveys jealousy. Make sure that the dots radiate from the head as if it were a vanishing point. And enlarge the dots as they travel outward. Note, too, that the dots get darker as they get large. All of this combines to give the effect of an actual stream of dots—or a stream of heated emotions radiating out across the room. Better not mess with her guy!

Clouds of Doubt

A patchy, sponge-like effect across the page creates the impression of emotional upset and worry. The mottled look should be uneven and dark. Will he leave her? Will he stay? The look on her face would not be nearly as grave were it not for the intensity of the background effect.

Daydream Effect

When a character is daydreaming, his or her head should partially overlap the dream sequence, which should be large and appear to be floating. The reader should be able to tell at an instant what is going on in the daydream. How do you show that? By keeping the character big in the daydream frame, for example, in a medium or closeup shot. You can make the daydream cloud any shape you like: round, bumpy, square, rectangular. But don't give it too many characters or a detailed background inside of it, because a cluttered daydream is tough to read. And then it begins to look real, not airy.

The Burst

A burst is one of the oldest, most famous and still most effective types of special effects. It's used for sudden thoughts, outbursts and sharp emotions. Think of it as a flash of light with characters standing in the middle. In order to show a flash of light, you have to have darkness—right? Therefore, any scene with a burst has to be a dark scene, punctuated with a flash. Keep your bursts jagged and uneven.

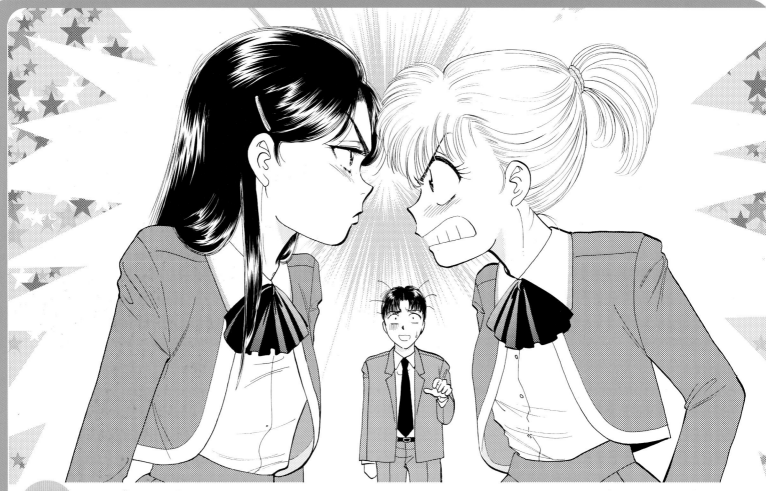

Broken Shards

Talk about a shattered relationship! Look at those sharp points invading the panel from all sides. Yee-ouch! Looks painful! In addition, there's a mini-burst where their two foreheads are about to collide.

Whatever set off the fuse between them, it's about to turn into one heck of an explosion. I think it may—just may—have to do with that boy in the background. If he's smart, he'll stay out of it!

Hint

Note the composition: A boy is standing between their friendship, figuratively as well as literally! Often, you can translate the emotional into the visual with basic placement.

Aroma Molecules

When a fragrance—or odor—wafts up from a bubbling brew, we know that a love potion is in the works. The witchy nature of this concoction is shown by the serpentine, curling lines. Dots work best, as solid lines tend to read as smoke or steam, not smells.

Red in the Face!

In comics, you can show a character getting red in the face without using any colors! Simply add sketch marks—usually diagonally—across the cheeks and darken the face with gray tones.
In this scene, her crush has just walked past her—but she can't think of a single thing to say to him!

Dramatic Streaks

Streaks equal urgency, which heightens the drama of any situation. But don't let the special effects do all the work. The scene itself has to be exciting, or it's like adding an exclamation point to a boring sentence—the audience won't be moved by it. Notice how the streaks start off darker toward the bottom of the cliff and lighten as they travel upward toward the boy—and safety.

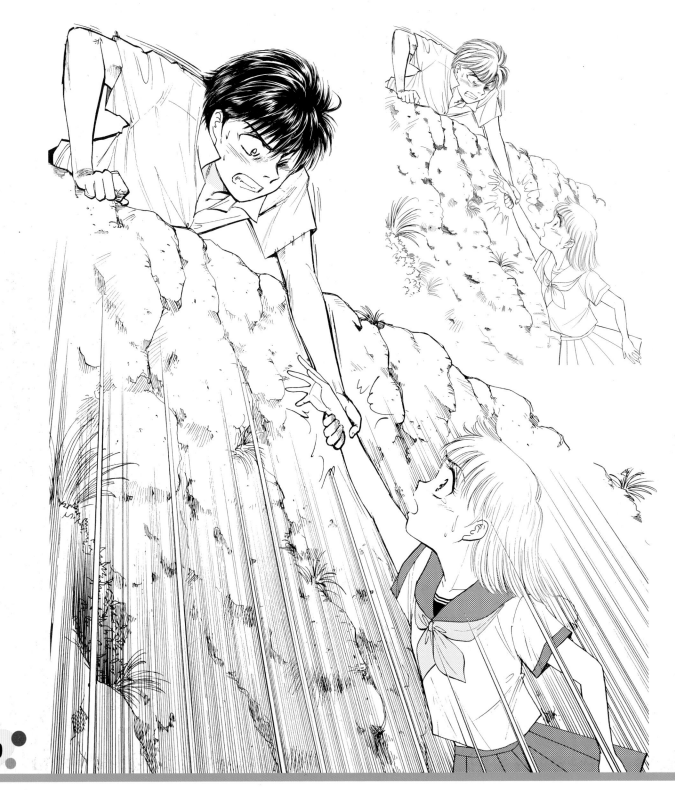

Flash of Light

This is a highly dramatic effect—a burst of ethereal light behind a character. It's laying on the drama pretty thick, but when the entire story leads up to one particular crescendo, you owe it to your readers to pull out all the stops. Notice how all the streaks point to the center of the action. Now you're really directing the reader's eye. As the artist, you're in charge, like a movie director.

His girlfriend has been killed by an evil warlord! This is the worst news anyone could ever get—especially since the prom is only two days away and he doesn't have a replacement date!

Speech Balloons

The placement of speech balloons is fairly informal in manga, unlike in American comics, where formal principles of layout and composition dictate the approach.

However, there are some basic conventions and attractive options for using speech balloons that I'd like to share with you, so you can use them in your stories.

Positioning Speech Balloons

There are three basic heights that work best for speech balloons.

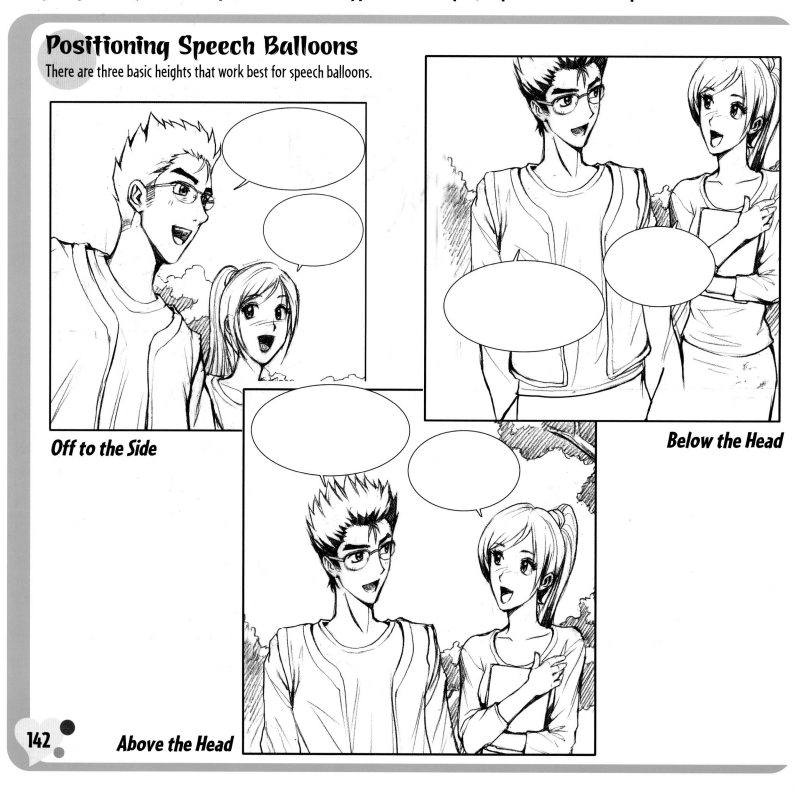

Off to the Side

Below the Head

Above the Head

When One Balloon Is Not Enough

Have you ever seen a speech balloon containing just tons of writing? Even if you could fit it all into one balloon—don't! It looks awful when it's so crowded—like a reading assignment for school. Remember, teens buy manga to escape reading assignments, not to get more of them! The best way to handle a long speech is to break it up into two balloons. Here are the three most popular methods for doing so.

Two Separate Panels

Two Balloons Within the Same Panel

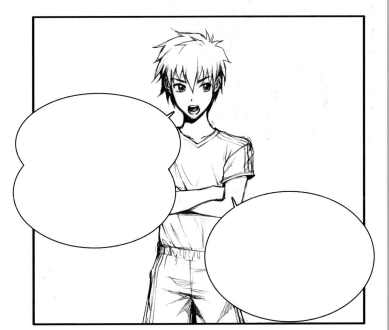

Two Balloons That Break Out of the Panel Borders

Special-Effects Speech Balloons

Now that we've learned about the effective placement of speech balloons, let's have some fun with them! Special-effects speech balloons are like speech balloons with expressions on them. They really bring out the attitude of the speech within the balloon. You'll find a much wider variety of these in manga than in Western comics. These light-hearted special-effects balloons are a great addition to the romance genre. The designs are mainly based on jagged balloons or uneven streaks in the shape of bursts of light.

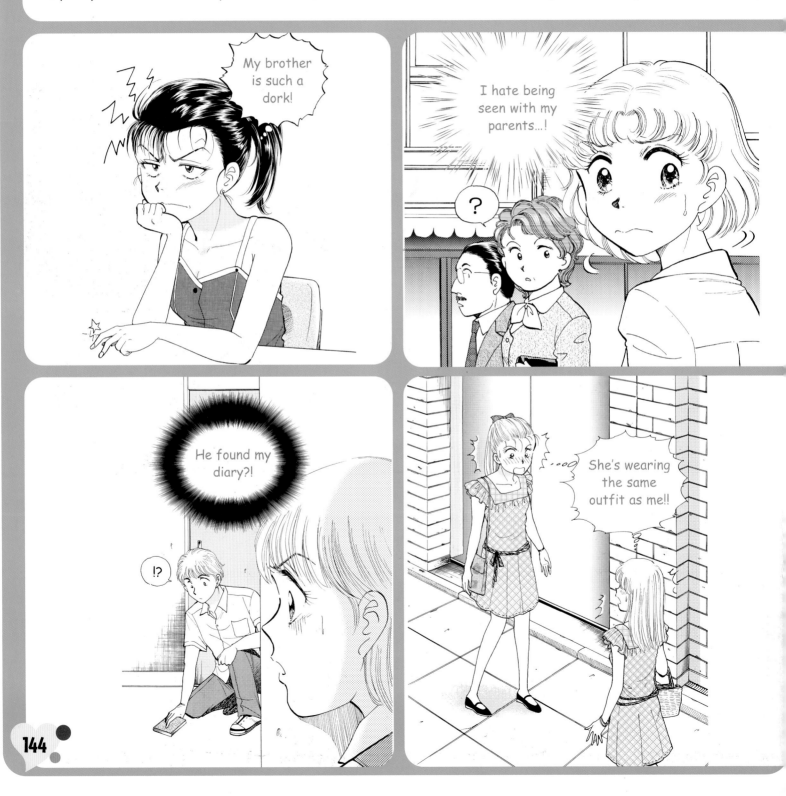

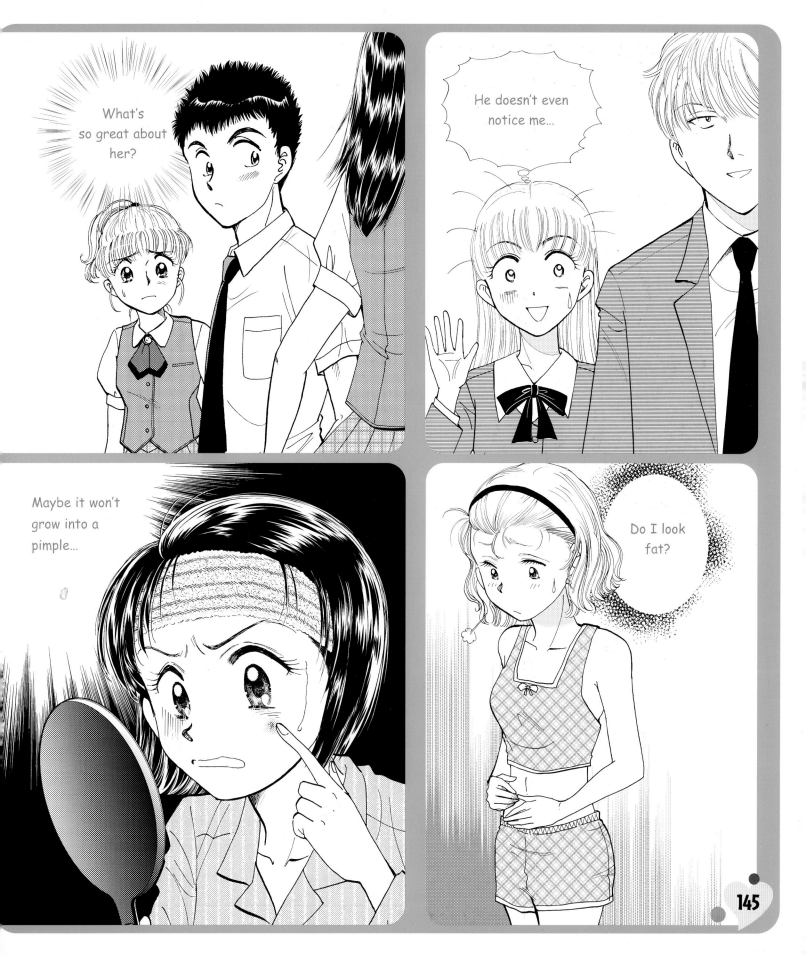

Japanese Sound Effects

Most manga graphic novels we read in the U.S. are translations from Japan. The words are written on a separate layer that can be removed so the text can be translated. However, the sound effects splashed over the art are part of the artwork itself, which is why they are still in Japanese, and why you never see words like "WHAM!" or "BLAM!" Japanese sound effects have no inherent meaning but are onomatopoeic, which means they sound like the meanings and emotions associated with them. Here are some common ones.

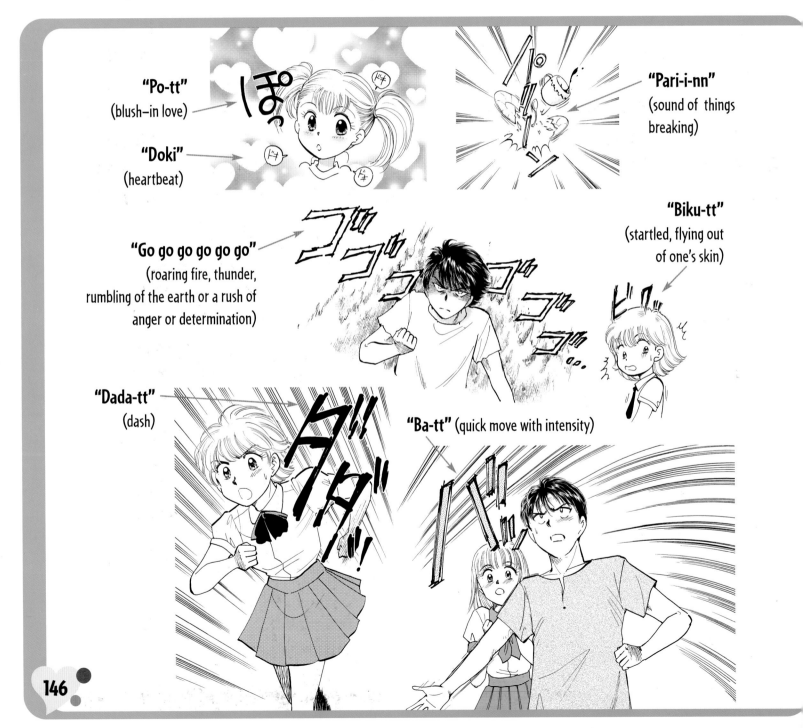

"Po-tt" (blush—in love)

"Doki" (heartbeat)

"Pari-i-nn" (sound of things breaking)

"Go go go go go go" (roaring fire, thunder, rumbling of the earth or a rush of anger or determination)

"Biku-tt" (startled, flying out of one's skin)

"Dada-tt" (dash)

"Ba-tt" (quick move with intensity)

Common Japanese Names

When creating a cast of manga characters, one of the things you have to do is give them names! And if it's a manga graphic novel, you can't very well call your characters Fred and Ethel. You need some common Japanese names. It also helps your story to sound authentic, especially if you're trying to sell your first graphic novel to a manga publisher. So here are lists of popular Japanese boys' and girls' names that you can use.

Japanese Boys' Names

AKIRA	JIRO	RONIN
BAKU	KAZUKI	SHIRO
GAKU	MASATO	TAKUMI
HIDEAKI	NAOKO	TOMI
HIROSHI	NATSU	WAKU
JIN	RIKU	YOGI

Japanese Girls' Names

AKI	HATSU	MITSU
AYAKA	HINA	NANKO
BENIKA	KAMEKO	NATSU
ETSUMI	LEIKO	NORI
FUMIKO	MACHI	RYOKO
HARU	MISAKI	SHINA

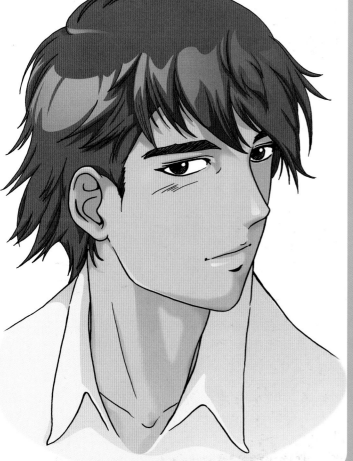

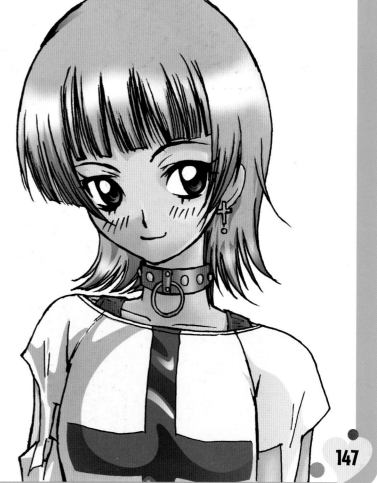

Also Available...

Look for these other great titles from Chris Hart Books! Available at bookstores or online at
sixthandspringbooks.com or chrishartbooks.com

MANGAMANIA™ FOREVER!

SKETCHBOOKS for sketching, journaling and more!

Manga Mania™
Fantasy Sketchbook

Manga Mania™
Shoujo Sketchbook

Manga Mania™
Chibi Sketchbook